EMMANUEL VAN DER AUWERA

EDITED BY
Harlan Levey & Amanda Sarroff

WITH CONTRIBUTIONS BY
Hans Maria De Wolf, Caroline Dumalin, Justine Ludwig, Ive Stevenheydens

MERCATORFONDS

DISTRIBUTED OUTSIDE BENELUX BY
Yale University Press, New Haven and London

A CERTAIN AMOUNT OF CLARITY

Our Bodies Are Temporary
Justine Ludwig p.5–10

Portraits in Absentia:
An Interview with
Caroline Dumalin p.13–27

FILMS p.29–107

Depictions of Future Memories
Ive Stevenheydens p.109–114

MEMENTOS p.117–167

The Aesthetics of Clarifying
Something that
Resembles a Black Hole
Hans Maria De Wolf p.169–174

VIDEOSCULPTURES p.177–211

Index p.213–218

Afterthoughts p.223–224

OUR BODIES ARE TEMPORARY

JUSTINE LUDWIG

OUR BODIES ARE TEMPORARY

Our bodies are temporary. This inalienable truth comes into sharp focus in the wake of tragedy. In our current, networked reality, painful reminders are routinely recorded and shared. Even at a distance, we adopt the suffering of others as our own. For Emmanuel Van der Auwera, the documentation of cataclysmic moments that lead to rupture, either on an individual or mass scale, becomes source material, pulled from an abyss of pain. Ruminations posted by regular visitors of a gore website, US military drone footage, front-page newspaper images of mourning, and video diaries of survivors of mass shootings all manifest in Van der Auwera's work to offer a multifaceted perspective on our need to witness and be witnessed. Acts of violence, either enacted or imagined, speak to human fragility and imperma- nence. Part of being human is the tension between our aspirations for immortality and the inevitability of our demise. Why not take a picture? It'll last longer.

Through the lens of screen culture—the Internet, television, video games, social media, and cinema—Van der Auwera reconfigures and recontextualizes all too familiar tragedies and traumas. In his hands, documentation is obscured, fractured, or cut apart and stitched back together. Each work is dominated by a unique intimacy, in which the artist obscures brutality while highlighting the means of its dissemination. His interrogation reveals how information, specifically that associated with violence, comes to be understood through images. Contemporary news outlets privilege these images through television, print, and social media, thanks, in part, to the democratization of photographic technology. Cameras are omnipresent, turning everyone into a latent photojournalist. The photo's pri- macy in "objective" documentation makes art a fitting avenue for reflection.

Van der Auwera explores what makes us human. To do so, he looks at the ugliest aspects of humankind—our bloodlust, anger, and attraction to cruelty. Often acting as an anthropologist, he investigates and unearths our darkest instincts. *Central Alberta* (2016), a film of a live performance, transforms chatroom transcripts from bestgore.com, a widely popular shock site, into the script of a found theater piece. It is based on a discussion thread where chat room regulars revealed what attracted them to the community in the first place. In this work, the audience are cast as chat room lurkers, silently watching those who dare to speak. The result is a tension between the observers and the observed. A few of the subjects talk about the empowerment of coming forward. As one Best Gore user says, "I hope everybody stays together through this bullshit and more lurkers come out from hiding."

The speakers candidly acknowledge their desire to engage with the site's explicit content, which showcases everything from minor accidents to acts of torture. These testimonies are conversational and often deeply conflicted. While Van der Auwera does not pass judgement, the subjects themselves are presented as if on trial. The film is a portrait of this taboo community created through the words its participants have left behind. The only edited soliloquy is that of the webmaster, Mark Marek. Van der Auwera pieces together disparate texts and takes some artistic license with their phrasing. Marek cuts a Mephistophelian figure, cruel and calculating. Hailing himself an oracle, he guides his followers through revelation, while fueling their lust for the unthinkable. He defends his actions under the guise of truth or, in the webmaster's words, "uncensored reality."

A CERTAIN AMOUNT OF CLARITY

VideoSculpture XI (Central Alberta) (2016) is an alternative presentation of Central Alberta that draws the spectator deeper into the act of looking and the apparatuses of seeing. Here a bright, white screen is mounted on the wall, while a circular black piece of glass rests on the floor below. Though no images are visible on the screen, the dark glass is like the edge of a well, into which we peer to see the actors speaking. These white, seemingly blank screens are ubiquitous across Van der Auwera's expansive body of "VideoSculptures," and it is only through the use of detached, polarizing filters that their images are divulged. *VideoSculpture XII* (2016) presents predator drone footage from bombing runs. In order to witness it, however, viewers must position themselves in close proximity to transparent plexiglass panels mounted on tripods. Looking through these viewfinders, they are given a "bomb's eye view." The challenge, once met, offers an unwanted reward. The artist transmits the painful meta–truths of his research process in the form of a parabolic warning.

There persists a powerful, if flawed, belief that a photograph or video shows things as they are and provides a more reliable annex than memory. In his "Memento" series (2016–present), Van der Auwera intervenes in offset newspaper panels mounted on aluminum, selecting and reassembling images and copy. What is left are photographs of masses in mourning. Without context, each newspaper plate becomes a stock image, applicable to all catastrophes. An interchangeability of the emblems of tragedy becomes apparent, with each subject serving as an archetype performing the accepted meter of shock and grief. The people seen in "Memento" stand in for how we as individual citizens, and as nations, ought to respond. We see the range of human emotion condensed, prepackaged, and marketed for mass consumption. The tenants of four–quadrant film are manifested in real life.

Missing Eyes (2017) similarly evokes the cinematic but with radically different means and end. Van der Auwera reappropriates an ISIS propaganda video pulled off of LiveLeak—a site used to share illicit content ranging from celebrity sex tapes to images of people being burned alive. The recruitment film is disorienting in its slick high definition, with production value akin to Hollywood films. In the video, a group of child soldiers are tasked with infiltrating a Syrian castle to find and execute prisoners held inside. The artist's edit of the source material reduces our view of the film to pinpricks. Using pioneering software that tracks the eye movements of people as they scan an image, *Missing Eyes* only shows the parts of the video that draw the attention of our gaze; the source narrative takes a back seat as we search for meaning in their familiar iconography. Video stills at first glance could be mistaken for stars dispersed across a night sky. With minimal audio and limited range of vision, *Missing Eyes* remains deeply affecting.

Van der Auwera doesn't allow his audience to witness violence directly. There is always an intermediary. Either we witness the reactions of those viewing the disturbing content or we see and hear from those contending with its aftermath. In *Missing Eyes*, we are shielded by no less than fifteen pairs of eyes that watched the ISIS recruitment video in order to create the film's dispersive visuals. In A *Certain Amount of Clarity* (2014), a companion piece to *Central Alberta* and *Missing Eyes*, we witness webcam reactions to real murders. Most of the subjects, who are young, frame the experience as a morbid rite of passage. The artist's intervention allows us to experience trauma by proxy. As with "Memento," our minds fill in the blanks, while the distance lends itself to reflection.

OUR BODIES ARE TEMPORARY

Van der Auwera's works demand critical engagement with both distant horror and mediated intimacy. He expects and encourages skepticism, even refutation, of the loaded images we engage with on a daily basis. Simultaneously his practice brings into focus our dependency on that documentation as a stand-in for memorialization. *The Death of K9 Cigo* (2019) and its pendant, the virtual panorama *The Sky Is on Fire* (2019), were both created in response to the 2018 shooting at Marjory Stoneman Douglas High School in Parkland, Florida. They explore how the shooting's optics and subsequent trauma were adopted by a wider public as it rippled through digital space. Using direct documentation, news footage, and confessional video streams he culled off the application Periscope, Van der Auwera constructs (and deconstructs) a multifaceted and fractured portrait of localized and metastasized violence. It is a dizzying convergence of sincerity, vulnerability, and patriotism.

Groundwork on *The Death of K9 Cigo* began eight days after Parkland, by pulling footage off the Internet created in response to the shooting. The raw and personal videos give access to the observations of those in close geographic proximity. A man talks about the loss of his gun license. We visit the flowers left in remembrance at Marjory Stoneman Douglas High School. Masses converge at a March for Our Lives Rally. These are punctuated by police body cam footage of the gunman ranting incoherently while being taken into custody.

The film crescendos with the memorial for a police dog, Cigo, who died in pursuit of "bad guys" at a mall in Wellington, not far from Parkland. It is followed by a lip-synch of "God Bless the U.S.A" by an ardent Trump supporter. During the canine cop's eulogy we hear, "Death comes to all of us…and that is the natural

passage of life." Shortly after, the voice of Lee Greenwood proclaims, "And I'm proud to be an American, where at least I know I'm free, and I won't forget the men who died, who gave that right to me." Death is inevitable. Its sting is allayed, if only briefly, by rituals of commemoration. *The Death of K9 Cigo* ends with the burning of a chapel installation in Parkland by artist David Best. Best's memorial invites communal catharsis, but the aftershock endures. Personal trauma spreads, begetting communal trauma, and in its wake, we see a society transformed.

What this transformation may look like, or may become, is hinted at in *The Sky Is on Fire*, where countless photographs, taken by the artist on site in Parkland and around Miami, are used to construct a three-dimensional landscape. The resulting installation feels like an apocalyptic video game, not yet fully rendered, the frame dominated by splintered digital detritus. The audio track, taken from a confessional video posted on Periscope, ruminates on the impermanence of human life. The speaker, whose voice we also hear in *K9 Cigo*, posits that, while our physical selves are temporary, the digital artifacts we create and the physical landscapes that we surround ourselves with will last indefinitely. "Our bodies are temporary, but what we do is permanent," he proclaims, "this is the digital age and it is all saved." Like this video, the surfeit of digital documentation that we each produce extends beyond our physical confines. We are building the memorials to our future selves.

For the subjects of *Central Alberta*, both the film and the video sculpture, for those captured in the "Memento" series, or for the actors of *Missing Eyes*, their documentation will long outlive their bodies. Van der Auwera's interventions

A CERTAIN AMOUNT OF CLARITY

both augment and complicate the legacy of that content. Broadcast through time and space, the original authors and their hold on interpretation are removed, transforming the viewer from passive consumer into active arbiter. The work is born, time and again, through the ever-changing prism of now. Van der Auwera's investigations resonate with the most pressing issues of today, ranging from the dwindling freedom of the press to the expansion of the surveillance state. What once shocked us is accepted as commonplace in 2020. Now, under global pandemic, most everything is experienced from afar. Before we accept this "new normal" we must question how these images of today create a false illusion of consensus.

PORTRAITS IN ABSENTIA:

AN INTERVIEW WITH

CAROLINE DUMALIN

Emmanuel Van der Auwera's films gravitate around something missing—a subject, an image, or an event in absentia. At the intersection of documentary and dramaturgy, he brings the real into a state of disappearance, urging us to question the image world as it begins to overlap with physical space. In this conversation, the artist looks back at seven films made between 2014 and 2019 that attest to an archeological observation of the present. In the use of new social technologies, Van der Auwera sees a reflection of archetypal impulses, from the desire to make representations of our world, to our fascination with cruelty, the performative nature of tragedy, and, ultimately, the human quest for immortality.

THE ECONOMY OF EMOTION

Caroline Dumalin:

A Certain Amount of Clarity (2014) introduced a number of motifs that recur in your later films, among them youth culture and digital subcultures. In what way did it mark a turning point in your practice?

Emmanuel Van Der Auwera: The film compiles webcam footage of children and young adults watching the same murder video on Bestgore.com, a website dedicated to graphic images that in 2011 boasted an estimated 10 to 15 million page views a month. You could say there is a before and an after *A Certain Amount of Clarity*. My earlier films were constructed and staged. In *Clarity*, the artistic gesture was kept to a bare minimum, using only found, raw material. While making this film, I realized that I had discovered a terra incognita: another world, another humanity, new perspectives on the oldest, most fundamental experiences of suffering and compassion. But in this other world, the familiar feels unfamiliar. Children transgress a taboo and open a window onto something they are not supposed to see. There is a "missing image" at the center of the film, caught between the webcam's lenses and the spectator's gaze. A taboo image drawn in the negative, which is a source of both vertigo and reflection.

C.D.

We never see or hear this murder. The video's absence creates a focus on what isn't there.

PORTRAITS IN ABSENTIA

E.V.D.A.

It's an abyss! The murder video is a black hole, perceivable only through exploration of its edges. For this reason, I didn't watch the video myself, so the reality of it wouldn't contaminate this idea of an indecipherable unknown. The metaphor of a black hole is resonant throughout my work. I have always been fascinated by the aesthetic of the sublime. How do you represent something that is too vast to comprehend? How can you trace around a subject without naming it? *Clarity* documents a social media phenomenon where young people play a strange game of measuring their empathy. It is also an allegory of humanity's cruelty, complicated by a powerful desire to connect to the world. There is a metalevel to the film that goes beyond the recorded event. In biblical history, the taste for cruelty is already present in the first murder, when Cain kills his brother Abel. By removing all specificity related to this murder, it becomes all murders. The film is anthropological. It shows us something that has always been. It is a glimpse of humanity laid bare.

C.D.

The webcam footage shows responses that vary from shock and disbelief to symbolically–charged reenactments. Some children are openly pres-sured by their friends to bite down and watch the torture through to its end. What sense do you make of this perverse contract of looking?

E.V.D.A.

These kids watch the video because they want to confront reality, or what they believe it to be, as a rite of passage. They film

themselves as part of a competition in which they challenge us with the authen-
ticity of their emotional responses, but this is impossible to capture. The camera's
presence alters their behavior. It opens questions that cannot be answered:
Is it real? Are they pretending? Some of them dispute the credibility of the video,
just as we might doubt the credibility of their performance. These videos occupy
a separate sphere of consumption, with its own elite and critical commentators.
The business' main stakeholder is the spectator, but its currency is emotion.

C.D. How do you begin to plumb the depths
 of such a vast online network and the
 complex relationships it engenders?

E.V.D.A. I tend to see the Internet, or at least social media,
as a parallel world that has recently descended upon ours, where the people
act and speak a little differently but tell us about how they behave in real life.
This virtual world is becoming more tangible than the real world, especially
as it bears an increasingly direct, credible, and perpetual influence on our physical
reality. The Internet's illusion of anonymity lowers psychological barriers, even
if it is precisely the place where we have none. My interest stems from a sincere
curiosity about how we expose, and thereby endanger, ourselves in order to
defy solitude. Social media serves as an antidote to loneliness—it is a way of
refusing to be an atomized being. But this hyperconnectivity also generates its
own isolation, which encourages clan mentalities and conspiracy theories. These
young people find their own communities of spectators who think the same as

A CERTAIN AMOUNT OF CLARITY

them. Cherry-pick your reality! But I'm not interested in just any content from
any place. These are images from the lowest depths pointing toward the surface.

THE FORUM AND ITS DOUBLE

C.D. *A Certain Amount of Clarity* belongs to a trilogy of films that reflect on the consumption of extreme images. The second film *Central Alberta* (2016) gives voice to several users of Bestgore.com. What inspired you to gather and stage these testimonies?

E.V.D.A. Best Gore gives visitors access to gruesome, explicit images. It also includes a forum where they can chat about anything. One discussion thread in particular caught my attention: "Why are you here?" It is quite a philosophical and existential question, and one that drew the community closer together. Even anonymous lurkers, who otherwise never comment, were compelled to respond. They talked about subjects as far-reaching as the war in Syria, but also about a personal search for meaning, and the hardships that had led them to the site. Reading it, I realized that the entire script of a play was there for the taking (except for the ideological diatribe of its webmaster at the end of the film, which I composed from different posts). By staging this material, I feel as though I elevated it from the virtual gutter to another level of readability. *Central Alberta* is a play about our drive to consume unbearable images, but one which withholds those images, instead offering only the faces of their witnesses. It probes the limits of what can, and should, be seen.

PORTRAITS IN ABSENTIA

C.D. You give a prominent role to the founder of this shock website, Mark Marek. What aspects of his character and motivations did you seek to highlight when you composed his script?

E.V.D.A. Mephistopheles speaking from the depths of his ice lake—that's how I imagine him. Central Alberta, the region in Canada where Marek is based, is extremely remote, with temperatures as cold as -40 degrees Celsius and Fahrenheit in winter. His dream, as he says at the beginning of his speech, is to live in hibernation in the wilderness. Marek is king of a small, virtual kingdom who commands deference from the acolytes of his site. There is something profoundly nihilistic about his message, but he covers his tracks by pretending to be politically motivated. Through the character of Marek, *Central Alberta* becomes an autopsy of a neo–political movement, the laboratory where notions such as alt–right, fake news, and post truth come into being. Marek talks about the utopia of transparency and calls himself a whistleblower; he presents himself as someone who will awaken the world, who feels the need to insert himself in great causes like a virus. In the end, he is little more than a pied piper who charms the youth and guides them toward his own obsessions.

C.D. The admission of feeling "desensitized" surfaces repeatedly in the individual testimonies. Do you see this absence of empathy reflected in society at large?

E.V.D.A. There is a reason why these forbidden images are
alluring. Visitors of gore sites want to see what is on the other side of the mirror,
familiarize themselves with horror and the ultimate unknown. But they will leave
something of themselves behind. How information is consumed today is desensitizing.
In that regard, *Central Alberta* is not just a micro–documentary about freaks who
obsess over graphic violence. It shows that an online forum is at once an extremely
closed chapel and an echo chamber of the much larger room we all live in. This
reflects a greater desire for outlets where opinions, no matter how outrageous, can
be expressed and validated—something we now see surfacing in the vocabulary
of upper–level politics. What before gave us a jolt is no longer enough. It's the
marker of an addictive consumption that always requires something more extreme.

C.D. You chose to work with actors this time. How
 significant was their role in interpreting the material?

E.V.D.A. I wanted to work with borrowed characters who could
lend voices and identities to people who hide in anonymity behind a screen.
During casting, I looked for actors who were conceivably around the same age
as those who had written testimonies and asked them to choose their roles.
They often picked the one they felt psychologically closest to. The film is a single,
long take of the play. During the performance, a very large screen was placed
before a camera in the center of a stage. Before the actors rose to deliver their
monologues, they sat among the audience. It signaled that potentially anyone could
be an actor. This specific setting was meant to highlight a continuity between

A CERTAIN AMOUNT OF CLARITY

the theatrical forum and the digital one. Just as an online forum can be populated
with those who only watch, the theater is a place where some express themselves
while others don't, but where everyone is a participant, including the audience.

SEEING IS REVEALING

C.D. *Missing Eyes* (2017), the trilogy's final work, also has an obscured image at its center, but this time the viewers, too, are absent. The film remains nearly pitch-black for its entirety. It is animated only by a swarm of dots that expose fragments of the underlying video, like flashlights scanning the surface of a landscape. What lies behind this abstraction?

E.V.D.A. *Missing Eyes* is a film on the edge of intelligibility, based on fifteen pairs of eyes recorded using eye-tracking recognition software. Volunteers were shown a promotional video by ISIS in which six children enter an abandoned castle to look for and execute hostages in a game of cat and mouse. Each viewer's gaze is a moving dot that allows you to peer through an otherwise darkened screen. We experience seeing through the eyes of others. The idea was not to show the film they are watching, but rather to obstruct it. It places a veil over images that should not exist, while at the same time asking critical questions about the act of looking and the responsibility it entails.

C.D. Why did you choose a film by ISIS?

PORTRAITS IN ABSENTIA

E.V.D.A. It is terrible to say, but ISIS's films mark a radical step. They are fluent in the vocabulary of ads, Hollywood fiction, video games, and music videos, but their objective is to choreograph real torture and murder. They reverse engineer the culture of spectacle to make a spectacle of death and maximize its effect on the viewer. ISIS videos are visual literacy's monstrous heir. The one used in *Missing Eyes* stands out for being particularly perverse while excluding gore. What struck me about this film was the idea of exploration, of diving deeper and deeper into a cave. In this video, different children descend into the ruins, but one gets the bizarre impression that it's always the same child. Like mental images that appear and disappear, it has the narrative progression of a nightmare.

C.D. What is the link between eye-tracking software and terrorist propaganda?

E.V.D.A. I worked with eye-tracking software that was developed by university scientists but is now used primarily for advanced marketing, which reflects our Western fetish of producing ever more effective images. Like commercial advertisers, ISIS employs seductive tactics to try to alienate or persuade its viewers. *Missing Eyes* is constructed entirely out of material provided by these two sources. The "flashlight effect," for example, was included in the marketing software as a tool to visualize gaze tracking that I then manipulated during postproduction. For me, these moving dots also recall the phosphene phenomenon that occurs when you shut your eyes, say, to avoid something you don't want to see. The title *Missing Eyes* refers to an alert that appears when the software can't detect any eyes. When you look away, for instance.

C.D. Throughout the trilogy you intervene progressively deeper into your subjects' modes of observation. Tracking people's eye movements is invasive—they can no longer hide or perform their reactions. How did you conduct this experiment and what were your findings?

E.V.D.A. I asked several volunteers to participate in an experiment at the intersection of art and science, with the caveat that they risked encountering violent or traumatic imagery. Following the screening we talked about what they had seen, and I showed them a printout of their eye movements. Although they had watched the film separately, you could observe clusters of gazes that followed roughly identical trajectories at similar speeds. It turns out that the image's architecture guided participants' eyes to specific places. The dots' speeds revealed that images are, foremost, mental ones. We recall seeing something, but we are not sure what, because it passes so quickly. When your eyes lock on a fragment, it's almost never figurative. Only belatedly do you realize you have just seen a gun, for instance. This taught me that we do not control our eyes; the act of looking is primarily a subconscious one.

A CERTAIN AMOUNT OF CLARITY

LIVE FOREVER ON THE INTERNET

C.D. *Wake Me Up at 4:20* (2017) deals with suicide on
 the Internet. Was this film inspired by real events?

E.V.D.A. *Wake Me Up at 4:20* is based on the stories of two
young girls who committed suicide online and became instant public celebrities.
I mostly selected video comments from people who had not known them personally,
so there's no way to be sure whether they actually existed. Their stories connect
loosely to an urban legend known as the Blue Whale Challenge, or Wake Me Up
at 4:20, which consists of fifty progressively self–harming tasks. It's a disturbing
game in which the players are ultimately instructed to kill themselves. Life, too,
is an escalating game of chance and risk, leading to certain death, but on the
vast stage of the Internet, people kill themselves so that they may live forever.

C.D. Why did you choose to conceal this cast
 of real individuals behind avatars?

E.V.D.A. I used 3D software to hide them behind archetypal
characters from video games, but their voices are authentic, and traces of their
humanity pierce their digital alter egos—in part because they are animated by facial
recognition technology that tracks their eyes and body movements. This tech-
nology, however, cannot accurately translate every emotion. The software's limits

cause the avatars to freeze and flicker, which in turn makes them appear all the
more human by reflecting the fragility of the person behind the mask. At one point
in the film, an avatar behaves like a blue screen and allows the girl that animates
it to appear. Like the uncanny valley paradox suggests, the closer we approach a
humanoid resemblance, the more our awareness of its artificiality incites discom-
fort and fear. I was interested in how aberrations of this new technological body
language made the subjects feel more relatable and enriched the dramaturgy.

C.D. *Wake Me Up* is shown on a mirror screen that super-
 imposes the viewer's own image, much like seeing
 one's reflection in a computer screen. How does this
 relate to the more direct confrontation between filmed
 subject and viewer in *A Certain Amount of Clarity*?

E.V.D.A. Both *Clarity* and *Wake Me Up* build on phe-
nomena born of social networks. They act as allegories for the Internet, this
hyperconnected world, and the isolation it engenders. People sit alone in
front of their computers—watching, speaking, singing—but they also act as
gateways to other levels of thought. This is where the two works diverge.
Wake Me Up deals with misinformation and the impossibility of knowing truth
from fiction, while *Clarity* raises anthropological questions about empathy.
Clarity is an image without any filter, while *Wake Me Up* is all filter.

C.D. You use video footage without the author's consent.
 Does this provoke any ethical dilemmas for you?

E.V.D.A. As soon as photographs are shared on social media,
they belong to companies, which instantly commodify them. If you want to observe
these images critically or make them speak on another level, you have to deal with
an untenable degree of censorship. To be an artist or anthropologist today is as
much a risk as it is a sine qua non. It is a journalistic axiom that the importance
of documenting an event of great magnitude takes precedence over one's personal
privacy. When a journalist takes a close-up of you in the street in the aftermath of
a terrorist attack, you forfeit the right to your own image. If we imagine that every
day is an attack in the making, then a portrait of anyone in public is permissible. But
at what point does this become reckless appropriation? Can I manipulate someone's
image to make them say something else? I ask myself these questions continuously.

A CERTAIN AMOUNT OF CLARITY

PATTERNS OF LEARNED BEHAVIOR

C.D. *Home* (2015) is based on an Internet meme that
 shows the homecoming of American marines. What
 interested you about this particular scenario?

E.V.D.A. *Home* coincided with the end of the Bush era and the
start of the Obama administration, when the United States was still significantly
deployed in Iraq and Afghanistan, and President Obama promised to withdraw
soldiers. It is a collection of roughly five hundred home videos of the same sequence:
a US marine returning from deployment and reuniting with his dog, while filmed by
a spouse. Each video follows a similar dramaturgy, a small roleplay exhibiting all the
physical details that can exhaust this scene. The clips are configured alongside one
another in different sections to form one, big 16:9 aspect ratio, and there is a kind of
mathematical variation to the way they appear and disappear from the grid. Assembled
together, I realized there was something tragic in the multiplication of these gestures,
a universality that transcends partisanship. We see soldiers upon their return from
deployment—a possibly traumatic experience that remains off–screen—undergoing a
social automatism. In this simple, intimate encounter, a cascade of complex emotions
plays out that attests to the programmatic expression of our joys and sorrows.

PORTRAITS IN ABSENTIA

C.D. A dog is central to your film *The Death
 of K9 Cigo* (2019) as well.

E.V.D.A. Dogs occupy a special place in Western percep-
tion. They belong to the nuclear family and are deeply anthropomorphized in our
society. *The Death of K9 Cigo* features the veneration of a martyred police dog,
honored for giving his life to his masters. I see dogs as a symbol of innocence
that helps make meaningless violence tolerable and relatable for the rest of us.
The dog's ritual glorification moves the focus away from a temporal order toward
something ahistorical that testifies to how we ultimately try to redeem ourselves.

THE CHOREOGRAPHY OF TRAGEDY

C.D. *The Death of K9 Cigo* revolves around school shootings in America. What aspects of these tragedies did you aim to capture?

E.V.D.A. *The Death of K9 Cigo* is an investigation into an event and its aftermath that seemed to defy reason: the Parkland school shooting in February 2018. Most of the content comes from Periscope, a social media application that allows users to post videos which erase automatically after several days. The app offers users a map of the world. I zoomed in on Miami, where I could watch and download thousands of people talking about what had happened. These fragments told a story that exceeded the brief lifespan of the news.

In the film, a multitude of images gravitate around the event and try to capture its intimacy, along with the normalized violence that resonates in the background. Beyond abstract concepts such as evil and innocence, I found answers in the tension between these hypermodern images and the performative rites of mourning. There are things that change and others that remain the same across humanity. In spite of all civilization's sophistica-tion, a prehistoric violence persists. We have learned to live with it thanks to the rituals that we have developed around it—but ultimately, we try to bury it.

A CERTAIN AMOUNT OF CLARITY

This is a film about the failure of the human project; the movement at the core of the film, from a school shooting to a dog's burial, is a cathartic illustration of that.

C.D. The shooting had just occurred. What triggered you to make a film in its immediate aftermath?

E.V.D.A. The Parkland massacre occurred two months after I visited Miami. I had already been working on issues related to school shootings in the US, specifically the crisis actor conspiracy movement, which posits that major media events are complex roleplays set up by the American deep state. This conspiracy theory is often revived following incidents that spur demand for greater gun control. A school shooting is something of a purely nihilistic, gratuitous, and desperate act. I imagined that an event of this magnitude would surely trigger an observable shock-wave through the lens of Periscope. Seeing how constellations of images on the app could produce meaning, I had the feeling of witnessing something hyperreal, too true to be believable. I felt challenged to assemble one viewpoint from this kaleidoscope of a million eyes, which says something too about how we digest mediated events.

C.D. How did you go about the complex task of editing?

E.V.D.A. The film's point of view is like that of an intruder, moving from the proliferation of lenses, from smartphone camera to camera, in an attempt to reconstruct a context. It was forged entirely in the editing process. I used brief video fragments to maintain a sense of urgency. The film begins as

an autopsy of this tragedy, which unfolds in different stages. With the introduction of Cigo, the police dog, into the story, it suddenly aims at something stranger and more difficult to grasp or define. It escapes mediatic gravity. I chose not to show any guns or sensational footage of the shooting. We see only a clip of the video made by the shooter, with the camera facing the ground where he had parked his bike. His speech is theatrical but insecure. His motives are not very identifiable.

C.D. The witness accounts you downloaded are no
 longer online. This lends the film the status
 of a document that goes beyond art.

E.V.D.A. I followed what was happening on Periscope almost daily
for over a year and gradually built up a substantial library of images. Less than 0.1%
of what I downloaded made it into the film. I was determined to preserve all this
material as if it were evidence or precious artifacts. But whereas in archeology objects
are dug up and brought back to light, here I was dealing with images in the light that
are disappearing into obscurity. After a certain amount of time, the videos disappear
from the app; this constant renewal is what makes the content more authentic.
Periscope is a form of amphitheater, where people come, speak their minds, and main-
tain their right to be forgotten. There is a movement and a mortality of information,
which adheres closely to our daily, lived experience. There is also something of a war
photographer in every person on this app, a dormant agent of this pact of the visible,
waiting to be activated by even the smallest event. They become active producers
of images, journalists of their own lives and of the world. It reflects a utopia of global

communication that transcends borders and channels. Like a message in a bottle, to
be discovered by anyone or no one at all. Whether anyone will care is another question.

DIGITAL ENTROPY

C.D. *The Sky Is on Fire* (2019), which forms a diptych with *The Death of K9 Cigo*, is a digital reconstruction of sites in Miami and Parkland, where the shooting took place. Why was it important to make a counterpart?

E.V.D.A. The two are separate films that intertwine, but one is not a continuation of or a commentary on the other. *The Sky Is on Fire* depicts a spillover of the image world into the real world, which is an idea that echoes in *The Death of K9 Cigo*'s multitude of cameras. I returned to Miami in December 2018, when I was already far along with *K9 Cigo*. I wanted to map the tensions and fragility that marked this place. I had been observing it so often and from so far away, as one does supernovas with telescopes, that I felt an urge and, I dare say, a responsibility to restore a certain tactility or physicality to this virtual map. If *K9 Cigo* is a film of extreme distance, *The Sky Is on Fire* is one of proximity, made by scouting streets of Parkland and Miami, capturing each individual element by hand as if collecting digital samples on site. Both films were achieved using a smart-phone, which is very significant to me considering everything we have discussed.

C.D. In this virtual panorama, which plays across three large-scale LED walls, we see the landscape increasingly disintegrate. You make use of a highly technological

A CERTAIN AMOUNT OF CLARITY

aesthetic that evokes an immersive video game experience. How did you arrive at this new medium?

E.V.D.A. *The Sky Is on Fire* is the amalgamation of many thou-sands of still images taken on site. To make it, I used a smartphone application that renders three-dimensional models of objects by folding and stitching photographs together. The app's algorithm deduces and reconstructs the shape of the photo-graphed objects. Its level of precision is insufficient, so distortions appear where high definition parts meet the angular ends of the photo. Everything that I captured from these streets ended up looking like a digital ruin. It becomes a film about entropy.

C.D. The streets are largely evacuated in almost post-apocalyptic fashion. A man's voice on the audio track is the film's sole human trace. The same voice returns in *The Death of K9 Cigo*'s opening monologue. In what way does this man connect both films?

E.V.D.A. There was something in his diction, in his frankness and humanity, that touched me. He is a narrator at the center of catastrophe, a troubled prophet who delivers a message of hope on the destiny of these images. In *The Death of KG Cigo*, he functions as a prelude to the film and echoes a great human despair. In *The Sky Is on Fire*, his monologue is filled with enthusiasm and technological mysticism. He talks about how technology will preserve and save us. He believes that people secretly welcome death and disaster, that our world will

not continue to exist ad infinitum, but that these recordings will outlive us. This vision aligns with notions of singularity and transhumanism—the idea that our salvation lies in a database that will digitize our consciousness and allow us to live forever.

C.D. From *A Certain Amount of Clarity to The Sky Is on Fire*, you follow the evolution of social media and the dissemination of images and narratives. What might the future hold in store for us?

E.V.D.A. In a few years, we will see images of people and spaces created entirely by artificial intelligence, wholly credible and perfected, based on material that was either captured or invented ex nihilo. How will we be able to cope with the spirit of disbelief in relation to the illusion that constitutes the very surface of such a world? The current revolution focuses on how to process an amount of information too vast for humans to grasp. For this, Google trains its artificial intelligences with every move we make. We all contribute to the development of these instruments. It is as if we are collectively creating a new leviathan, a being to which we will delegate matters that are too complex for us. But this titan transcodes in language that we may one day not understand. After all, these are tools to transcode human emotion and behavior at a scale that is, well, inhuman. Out of this overwhelming abstraction, I continue to search for the soft heart of collective human experience.

PORTRAITS IN ABSENTIA

A Certain Amount of Clarity

2014, HD video, 29 minutes 15 seconds

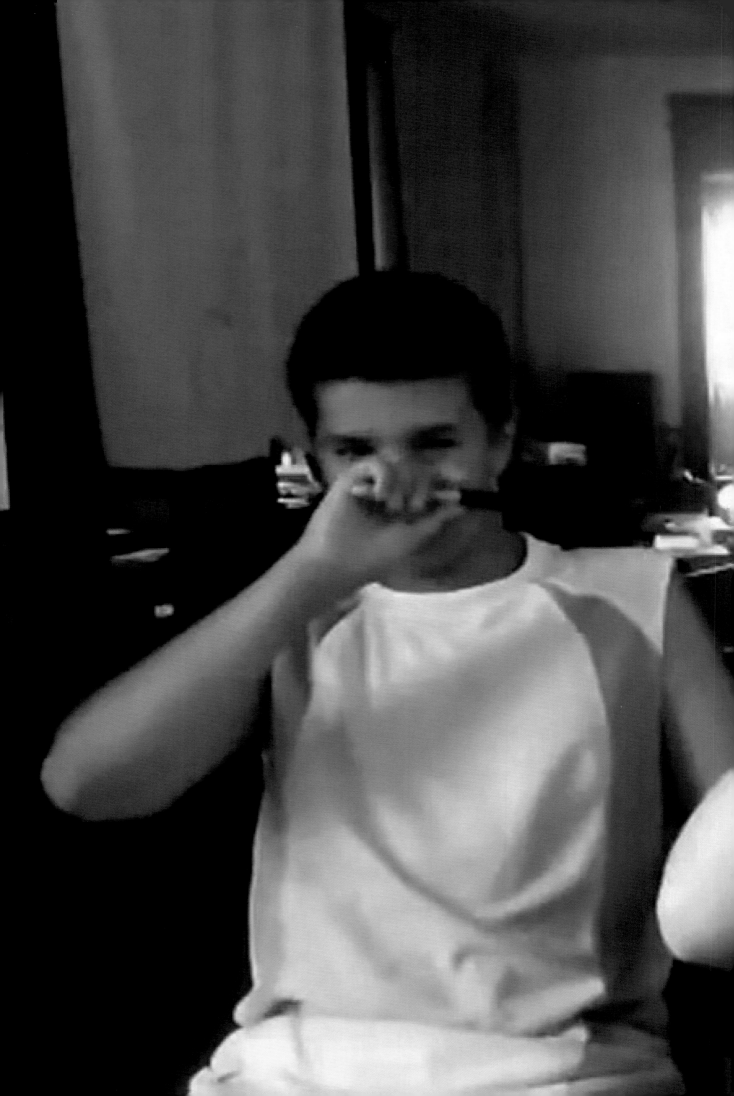

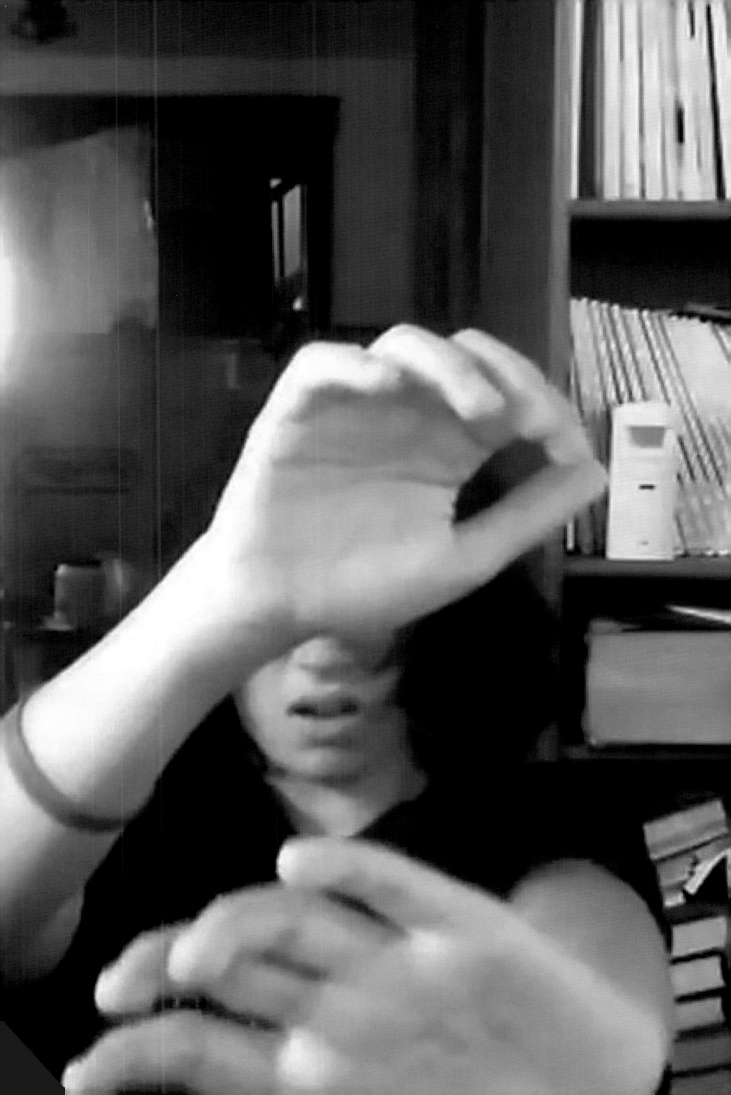

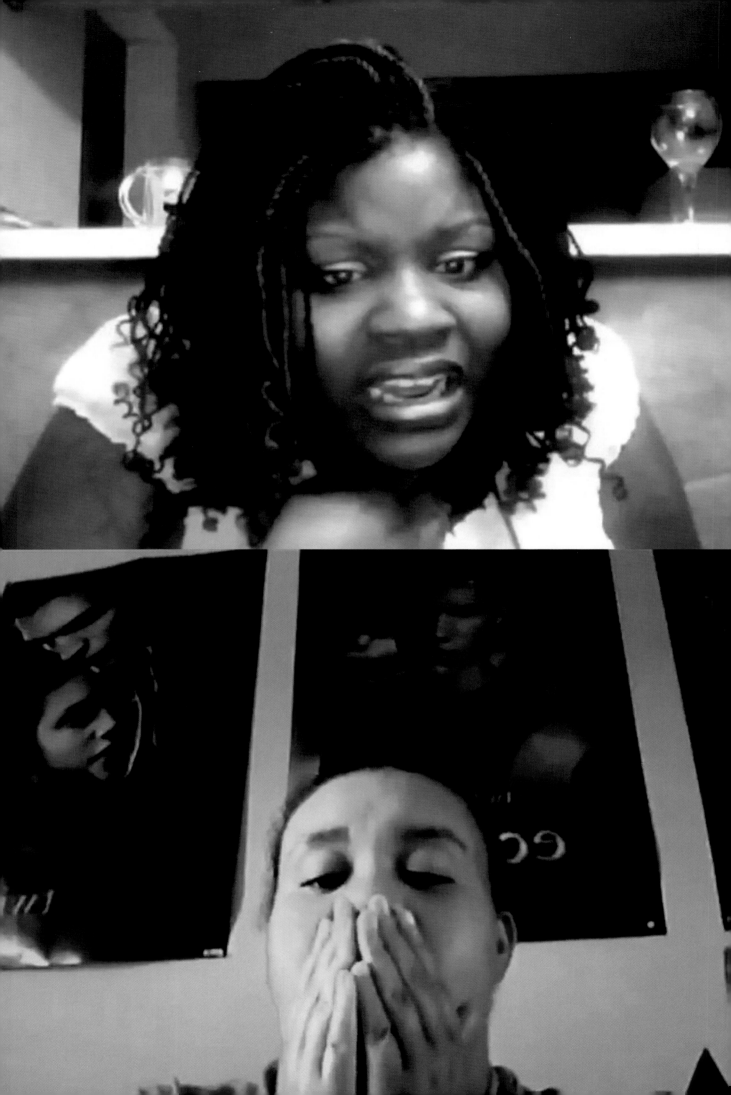

I wouldn't
you to lo

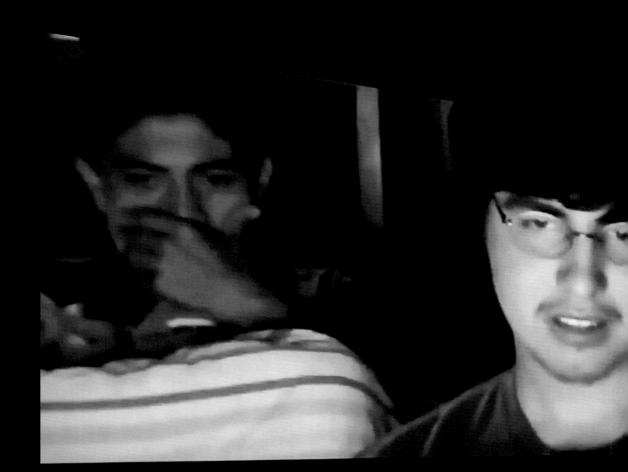

A Certain Amount of Clarity, installation view, Young Belgian Art Prize, BOZAR Centre for Fine Arts, Brussels, 2013

Central Alberta

2016, performance, 48 minutes
2016, HD video, 46 minutes 30 seconds

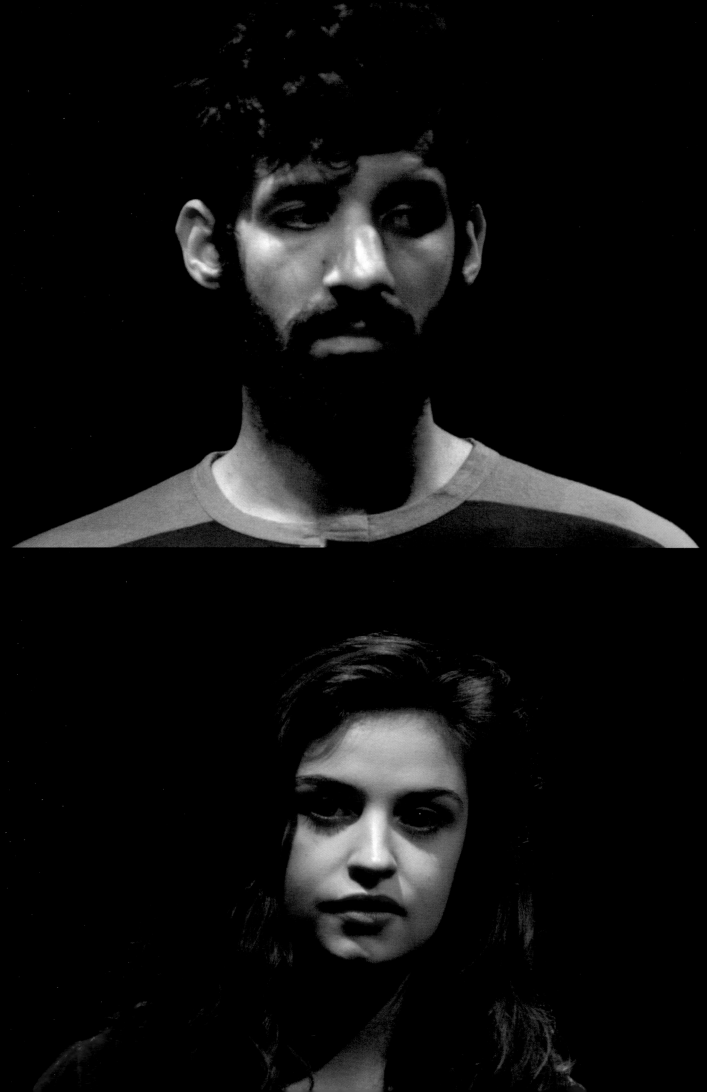

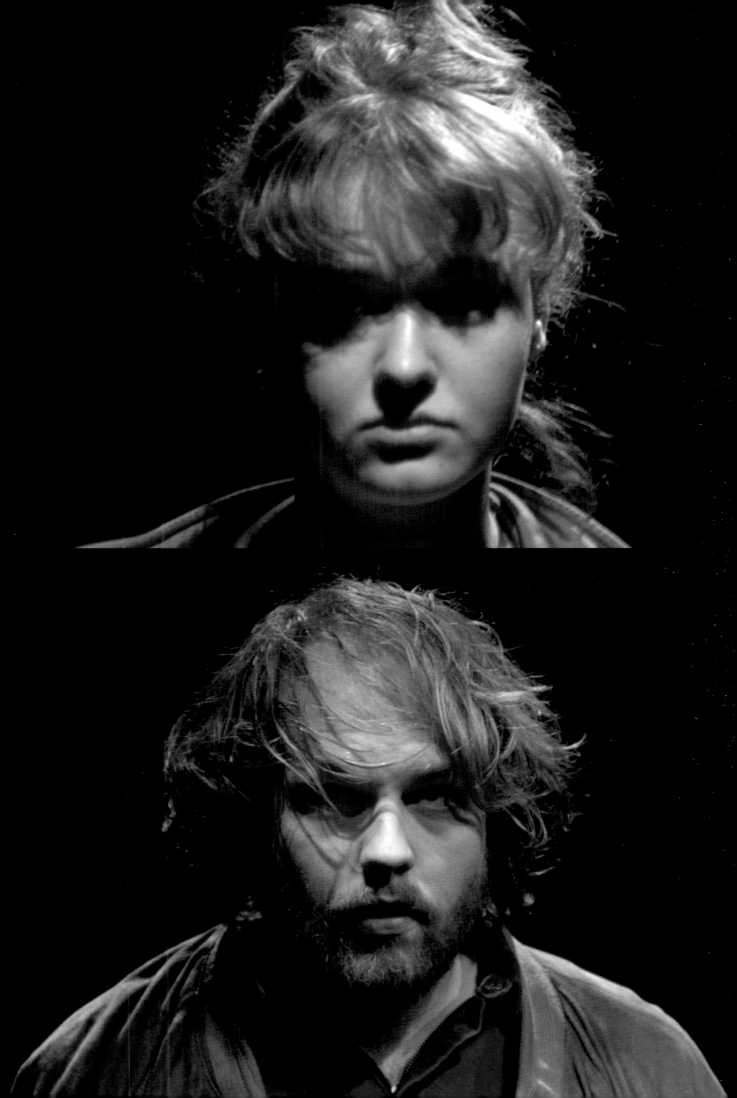

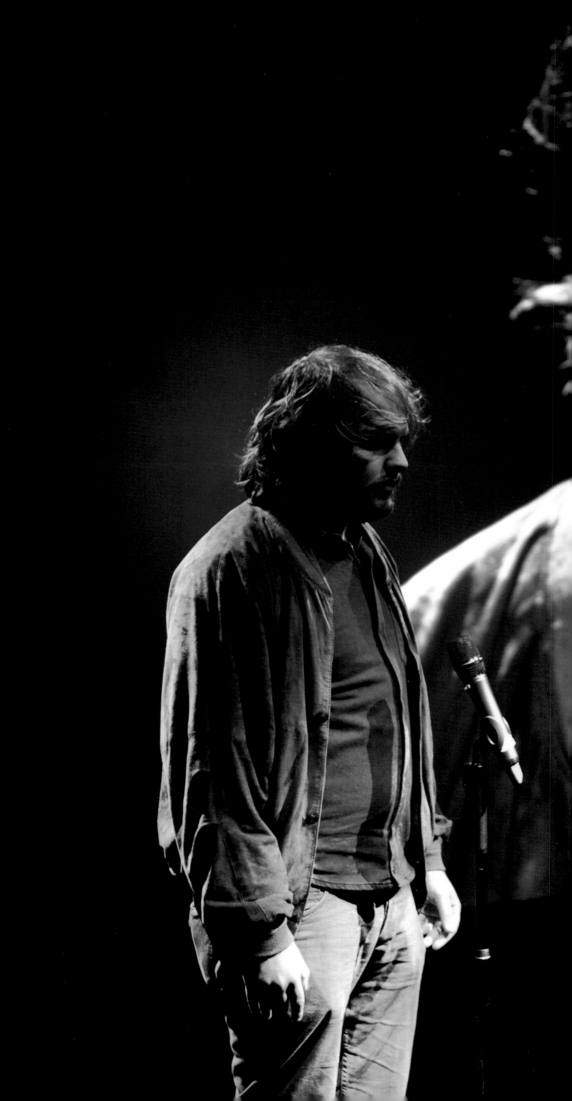

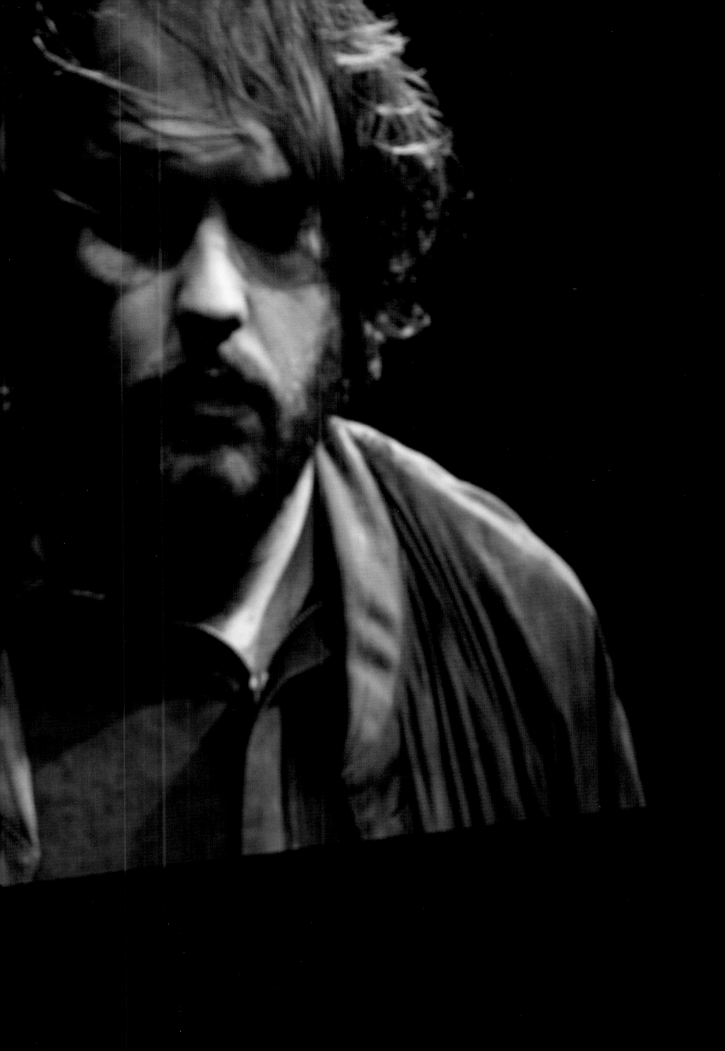

for a

Central Alberta, installation view, VISIO. *Outside the Black Box*. Lo schermo dell'arte Film Festival, Florence, 2016

Missing Eyes

2017, HD video, 14 minutes 21 seconds

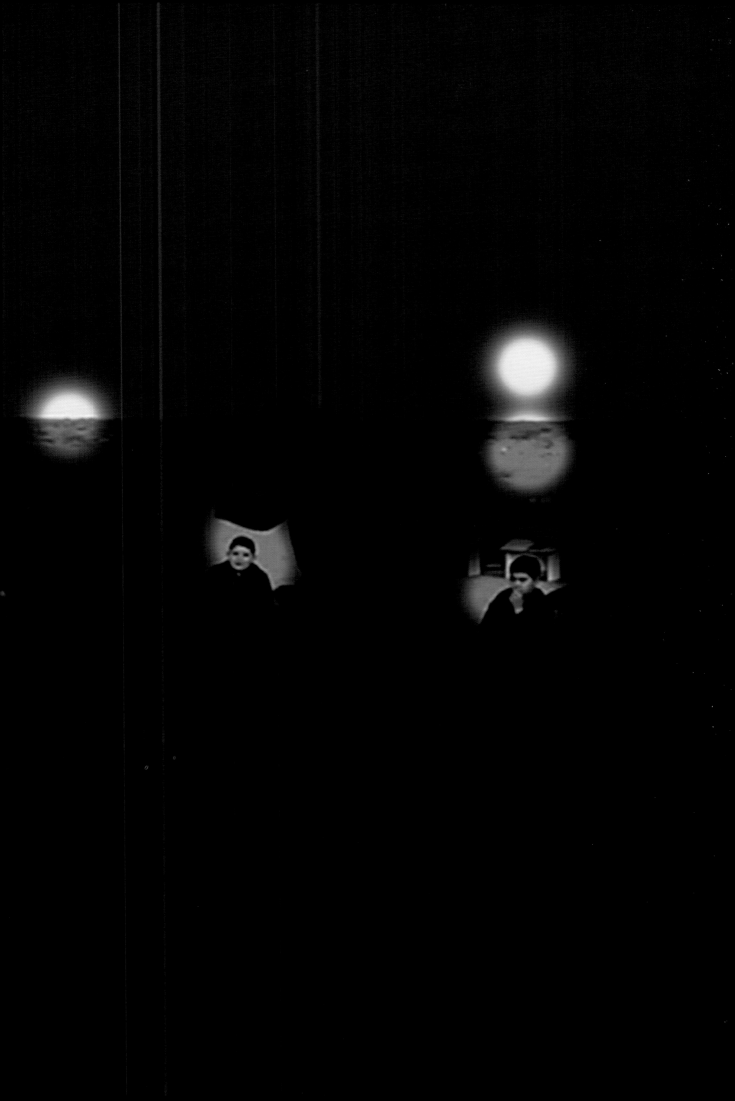

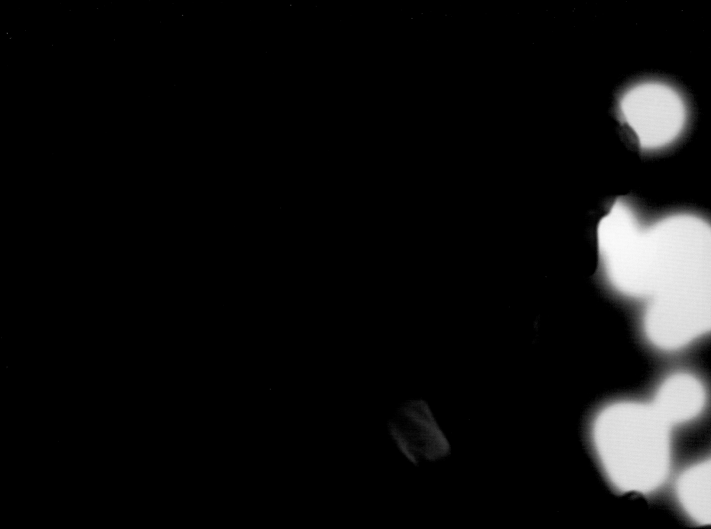

Missing Eyes, installation view, Emmanuel Van der Auwera – Black Box Series, ARGOS centre for audiovisual arts, Brussels, 2018

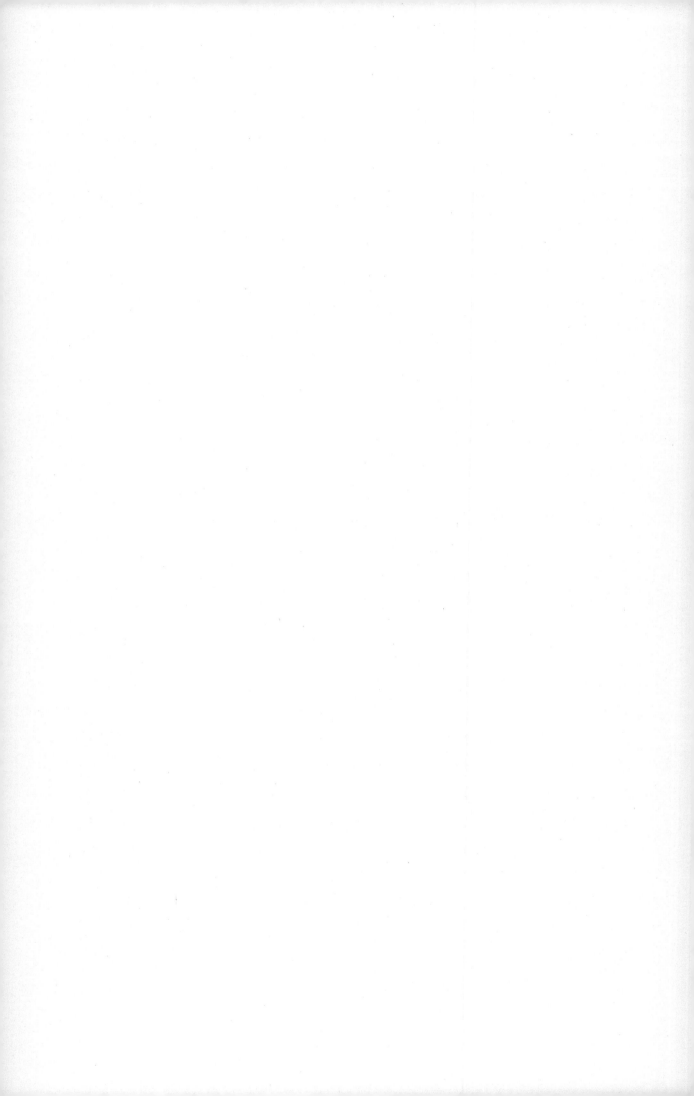

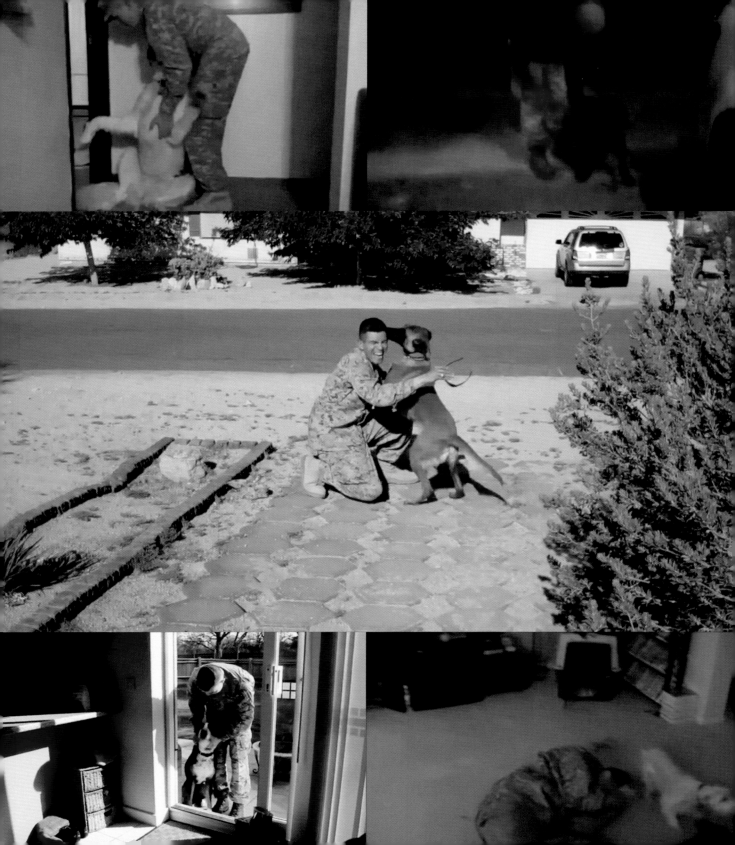

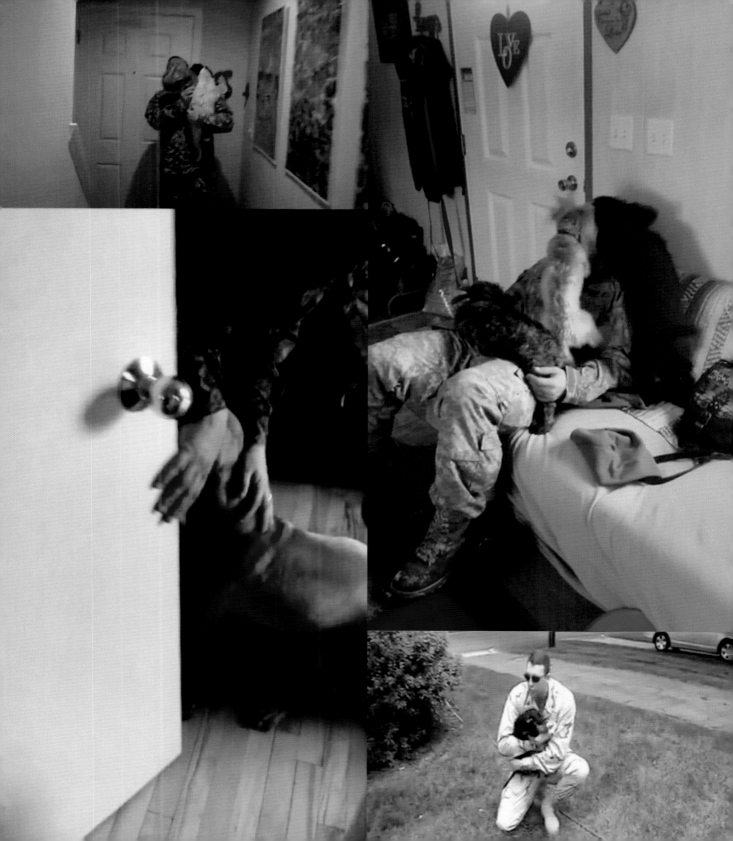

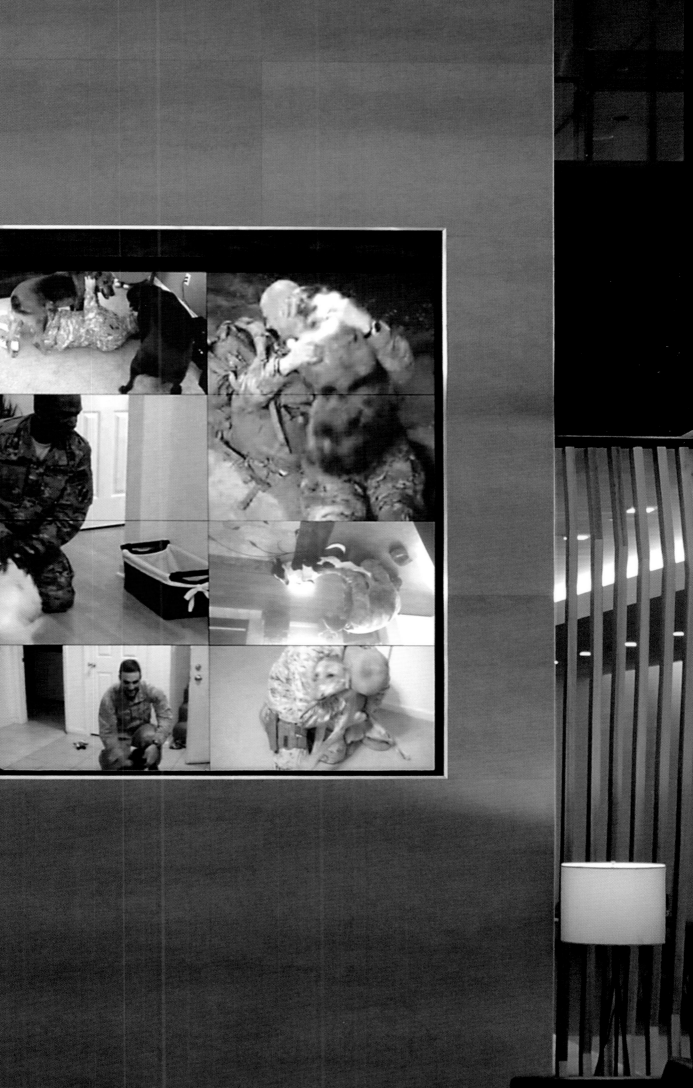

Wake Me Up at 4:20

2017, HD video, 12 minutes 22 seconds

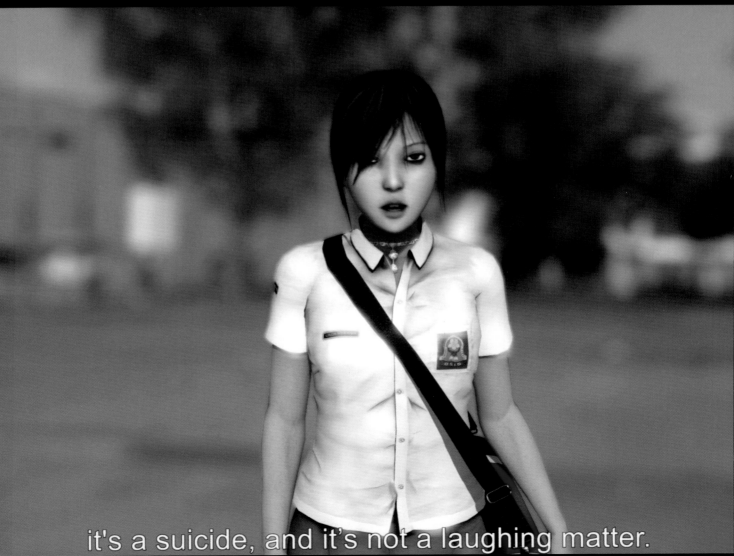
it's a suicide, and it's not a laughing matter.

ON THE INTERNET

YOU LIVE 4EVER

Wake Me Up at 4:20, installation view, *Blue Water White Death*, Mu.ZEE, Ostend, 2018

I didn't d

because

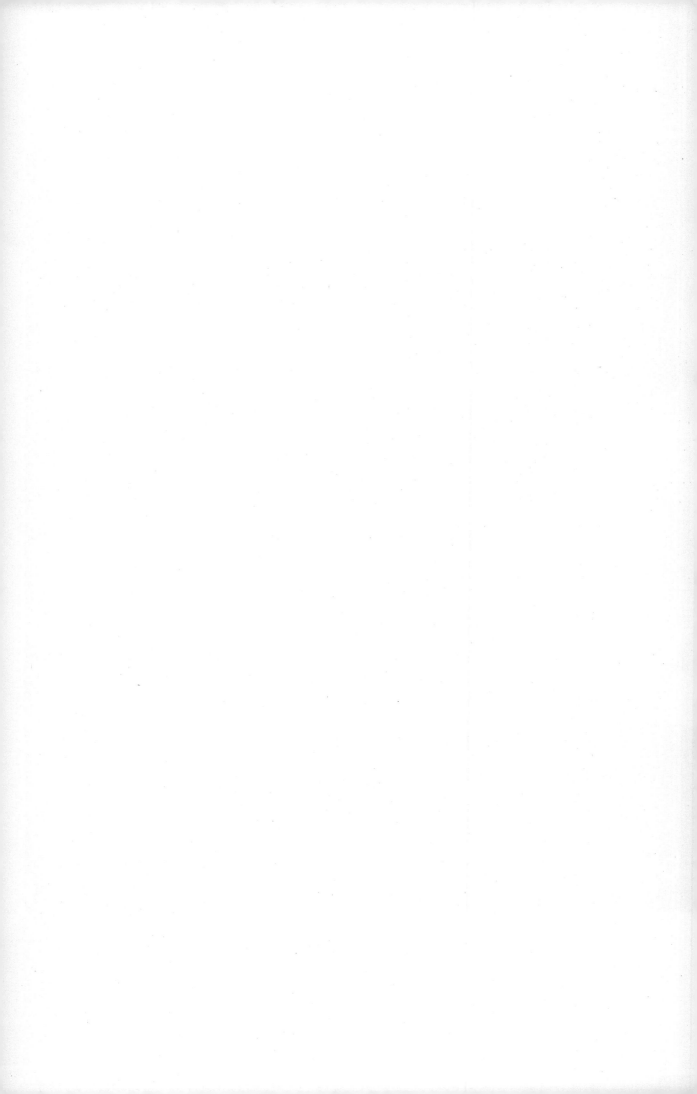

The Death of K9 Cigo

2019, HD video, 23 minutes 9 seconds

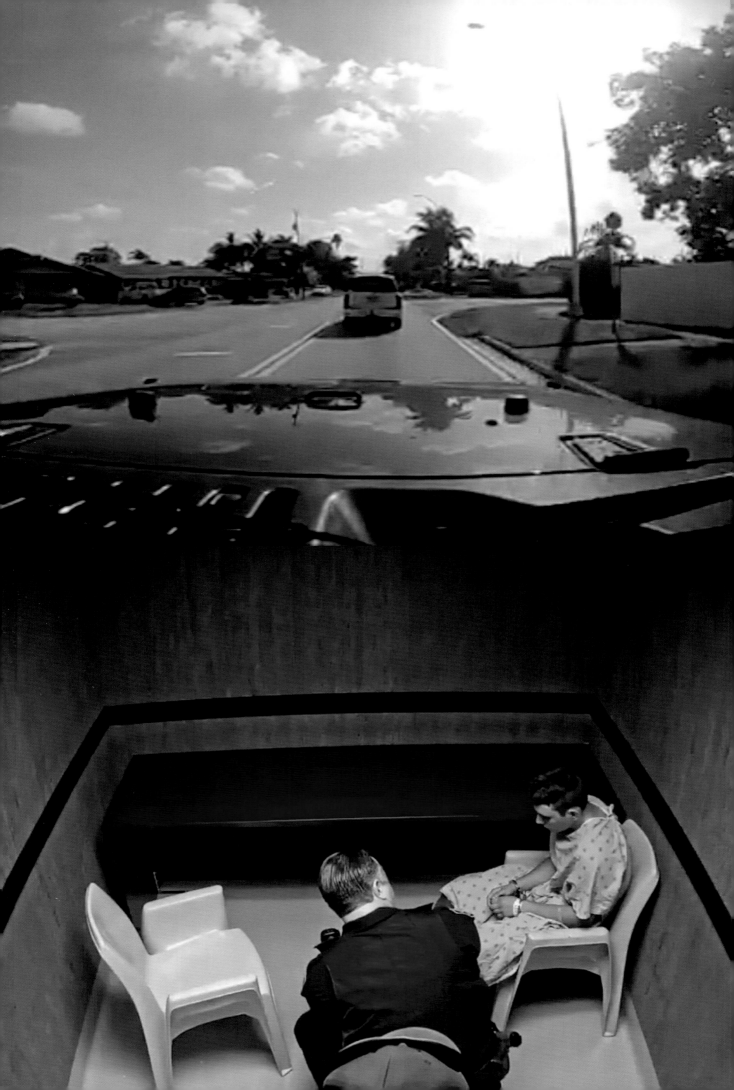

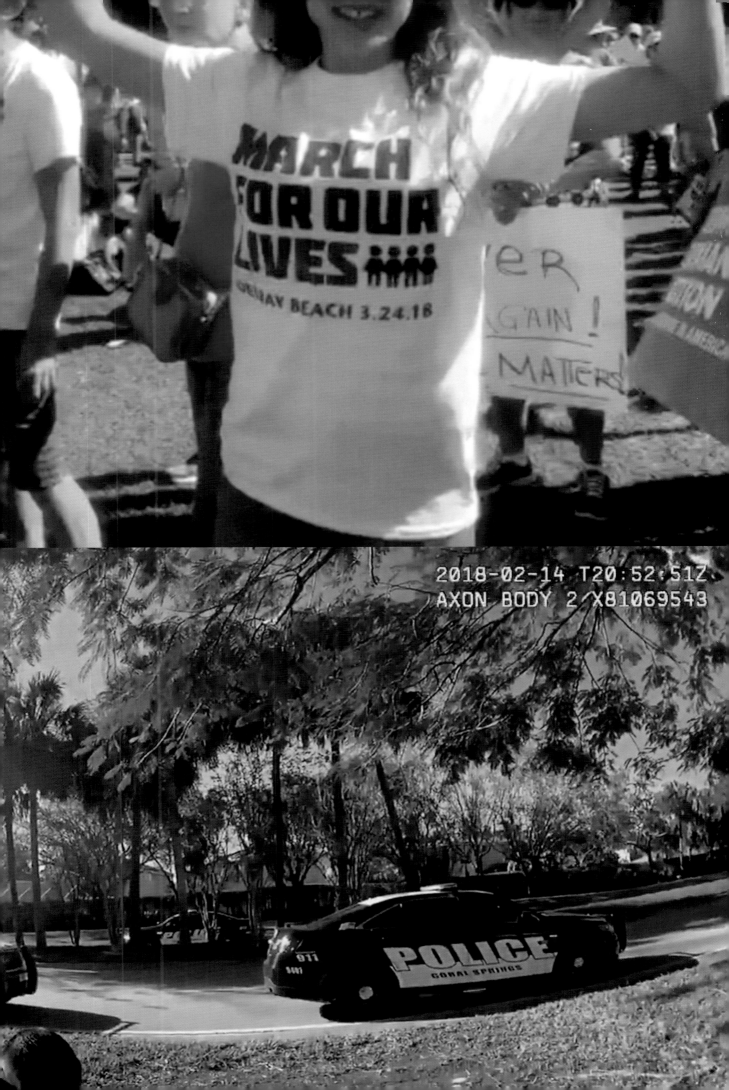

2018-02-14 T20:52:51Z
AXON BODY 2 X81069543

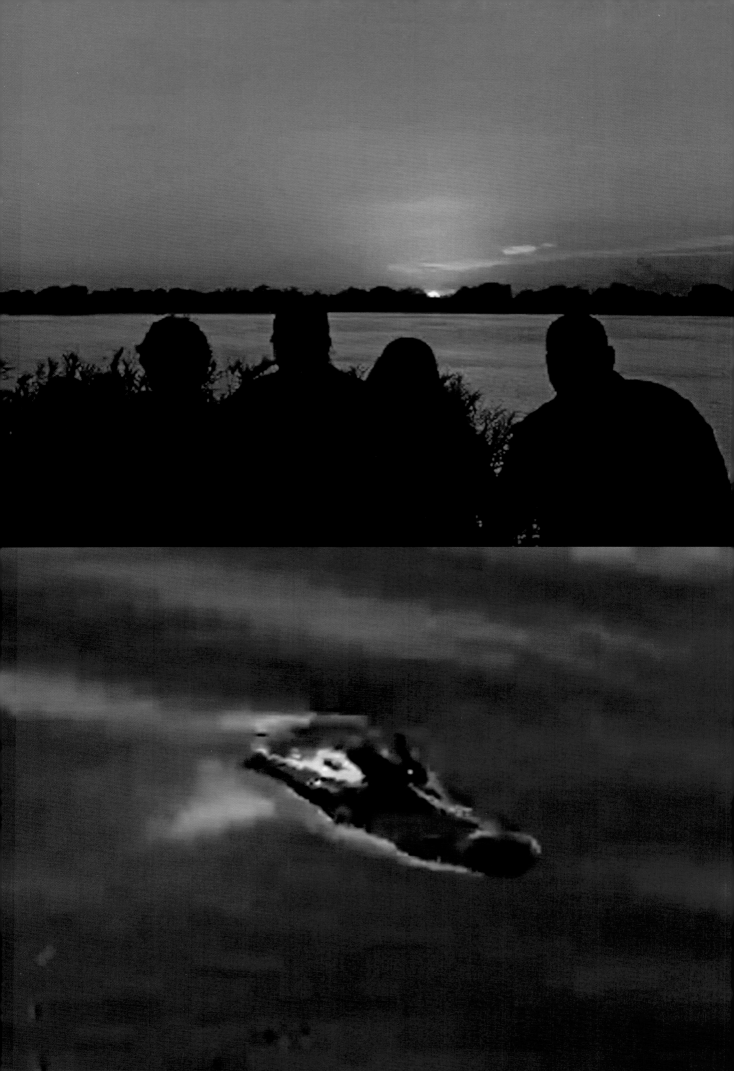

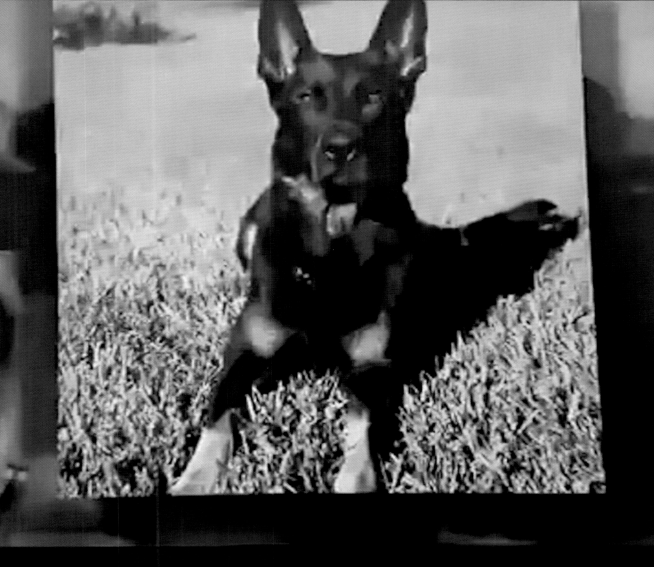

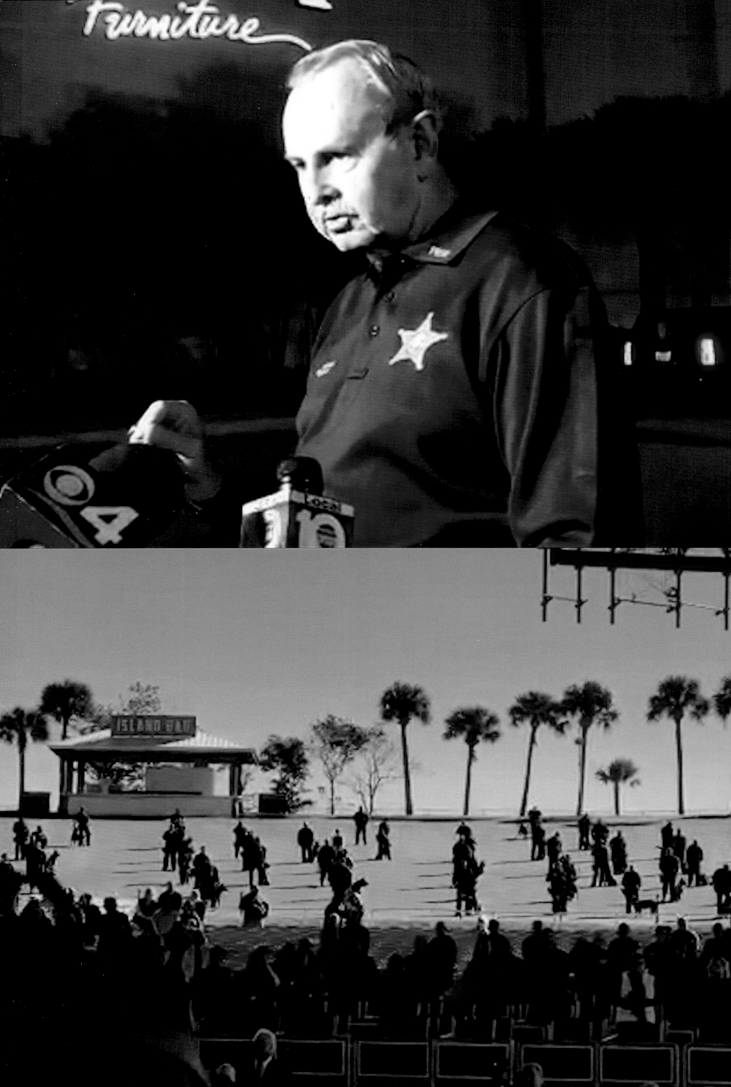

The Sky Is on Fire

2019, HD video, 15 minutes 21 seconds

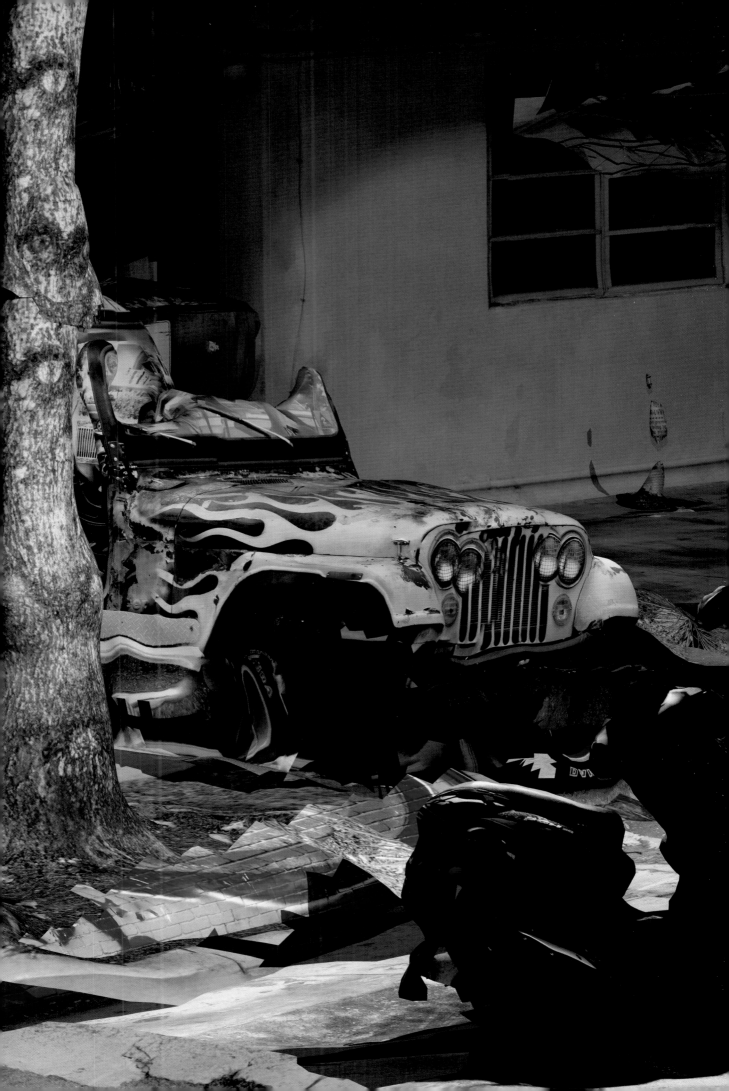

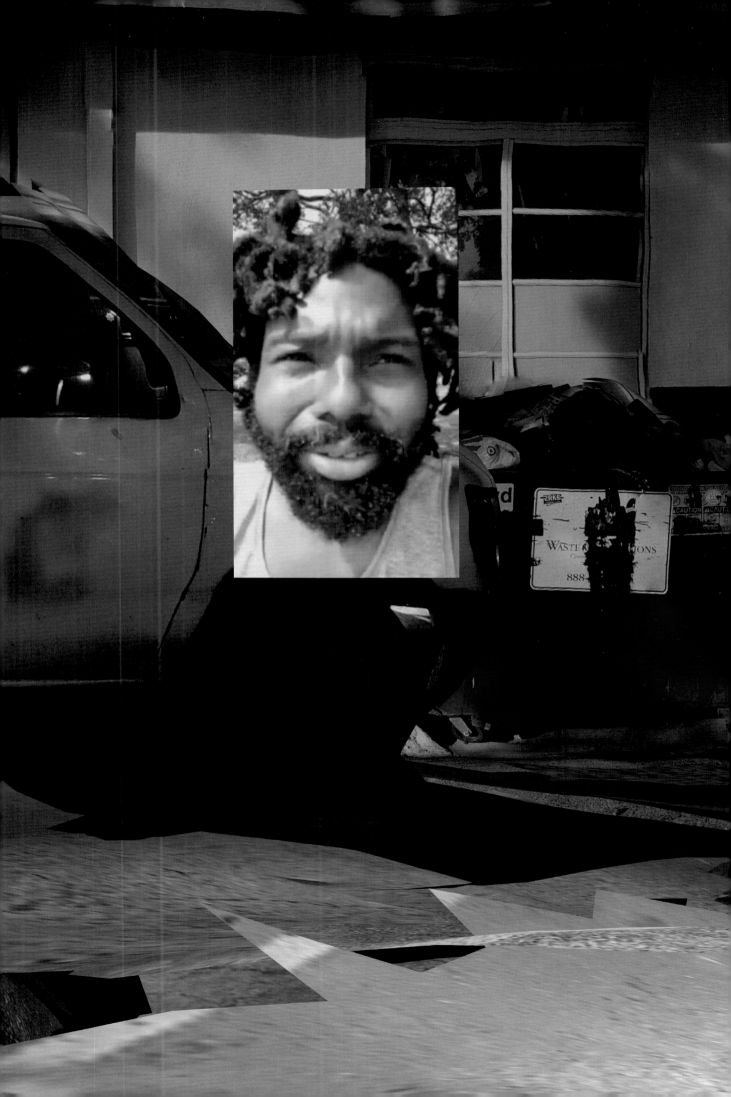

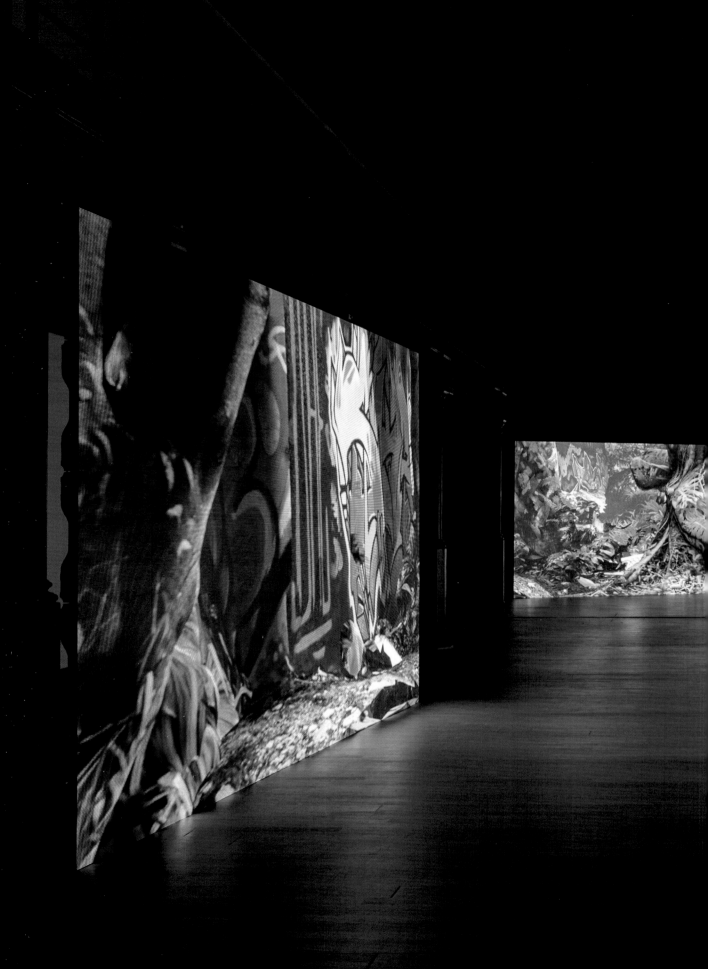

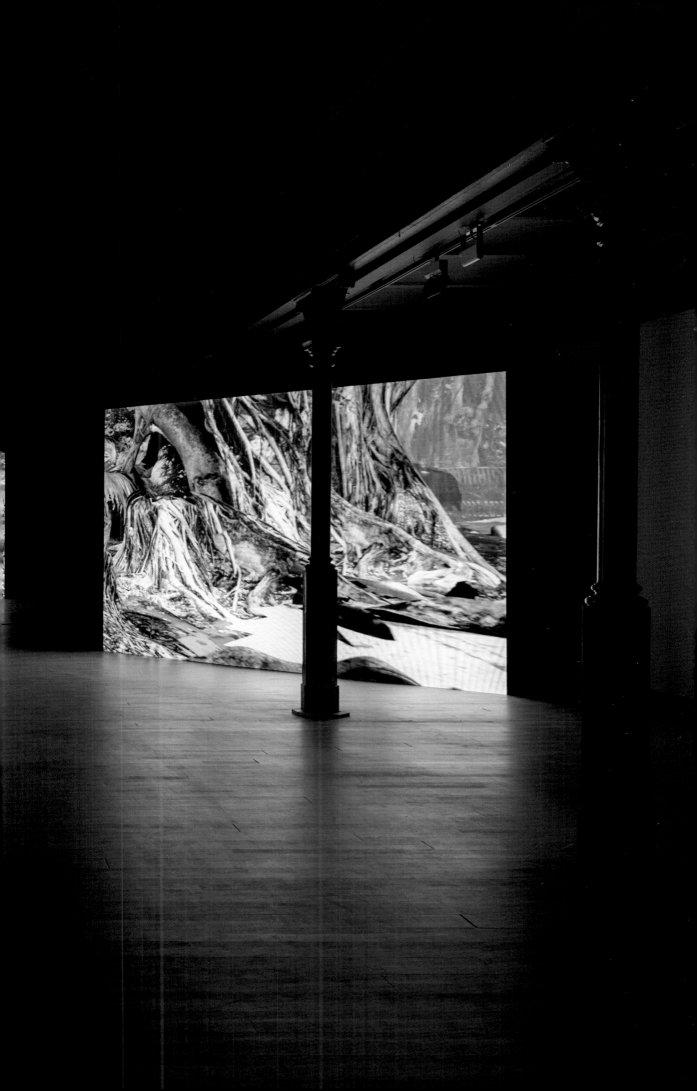

REPRESENTATIONS OF FUTURE MEMORIES

IVE STEVENHEYDENS

REPRESENTATIONS OF FUTURE MEMORIES

Blue is the color of the unreal, of
memory, of the open mind, of all things
royal, precious, and rare. Blue is the color
of the absolute, of the divine, of cold,
and of clarity. It is the color of Yves Klein,
Derek Jarman, Picasso, and Gerard
David. Blue—cyan, to be precise—is
also the color of Emmanuel Van der
Auwera's "Memento" (2016—present),
an ongoing, growing series of offset
newspaper panels mounted on aluminum.

"Memento" was born of a happy
coincidence, rooted in a 2013 work
titled *First without words*, "produced"
that year for the exhibition *O Superman*
at IKOB — Museum for Contemporary
Art, Eupen, curated by Maïté Vissault.
While searching for blank, unprinted
newspaper, Van der Auwera came across
reams that had been coated in a swath
of uniform colors. These turned out
to be remnants of a cleaning technique,
whereby white sheets are run through

the rotary press to remove excess ink.
The piles of folded broadsides, printed
in fading or degrading shades of blue,
green, black, or combinations thereof,
fascinated him. He recuperated a number
of them and, after careful selection
based on color and printing, look and
feel, exhibited several in the museum.

First without words renders the
invisible momentarily visible and delves
into a mass medium in the midst of
its decline. Formally, the work seems
to embody photojournalism's demise:
it looks like the residue of something no
longer alive. It also creates a sense of
wonder about the beauty of the everyday,
of waste well considered, of something
that otherwise remains hidden from view.
But there is more to it. These sheets
are purified, extracted, and distilled
representations. They are erased impres-
sions, wiped out realities, or "truths."

This melancholic anacrusis paved the way for "Memento," which intercedes directly in the printing process. In commercial offset printing (used for brochures, magazines, and newspapers), a page's layout is burned into an aluminum panel via a computer-controlled laser beam. The panel is coated with a light-sensitive emulsion that hardens with exposure. Though the emulsion can be any color, the industry standard is blue. Once washed away, the remaining images and text are printed in CMYK colors in four stages using a rotary press. Van der Auwera hijacks this fully autmized process, intervening at the precise moment where light strikes the emulsified plates and transforming the factory space into one, large revelation chamber.

Nowadays, graphic depictions of catastrophes are absent from news-papers. What is displayed instead are

Overexposed parts of the panel remained blue, while the protected areas turned white. What remained were semi-accidentally framed and cropped photographic prints with multiple layers, or remnants of the newspaper layout, filtering through the cyan. These were barely visible traces of what once was—or had never been—burned beneath an elevated image of the crowd. They placed the viewer in front of a theater, one seemingly stilled behind an ethereal blue curtain, frozen but in the making.

These early "Memento" works lay the conceptual groundwork for the artist's interest in mediatized representations of crowds. Following a tragedy, he noticed, newspapers portray masses shrouded in attributes of mourning: demure postures, pained expressions, eyes fixed on the ground or directed upward, toward some imaginary point. How do catastrophic events write themselves into collective

A CERTAIN AMOUNT OF CLARITY

full frontal images of those in an act of witnessing or grieving. These, along with the headlines that accompany them, come to stand in for the events themselves and the emotions they are meant to evoke. For his early "Memento" works, Van der Auwera would visit the *La Libre Belgique* printing press in the short aftermath of a highly mediatized tragedy.[1] He would remove the already exposed panels from the machines, strategically cover the areas he thought to contain images, and expose the rest to white neon light. The plates would then be dipped in a chemical bath, much like in a darkroom, and the image revealed.

memory? Wherein lies a possibility for a common imagining of the future?

News is built through a process of storytelling that is co-driven by marketing; events produce meaning that can then be churned into content. This type of journalism not only creates a figurative mise-en-scène, it belongs to a literal mise-en-page, which ultimately forms a mise en abyme that allows the situations depicted to be deconstructed. Chance plays another important role. Van der Auwera's deceitfully simple interventions reveal a pointed analysis of how the automatized system of

1
Namely the shooting in a nightclub in Orlando on June 12, 2016; the failed coup in Istanbul on July 15, 2016; the bombing in the Saint Petersburg metro on April 3, 2017; the suicide attack carried out at an Ariana Grande concert in Manchester Arena on May 22, 2017; and the attacks in Barcelona on August 17, 2017.

2
Susan Sontag, *Regarding the Pain of Others* (New York: Picador, 2003), 52.

3
Some newspapers and magazines now publish these kinds of images only online, on their own homepages. Just as with the scenography of old media, new media has its own règles du jeu. In fact, the two are constantly leapfrogging: they inform

one another, learning dirty tricks to com-municate their messages even more loudly, in yet other—preferably "new"—coded forms. There is no such thing as pure journalism or bare news. There is only opinion. Moreover, news will always have to sell. This is why public opinion and questions to the reader/viewer/recipient are progressively given more space and virtual attention under false banners of interactivity. Much of the information

newsgathering and processing has itself become inscribed as a cultural memento. In the words of Susan Sontag,

> Strictly speaking, there is no such thing as collective memory—part of the same family of spurious notions as collective guilt. But there is collective instruction.... What is called collective memory is not a remembering but a stipulating: that this is important, and this is the story about how it happened, with the pictures that lock the story in our minds.[2]

The media's recurring, rote scenography used to depict or instigate collective suffering is a way of appropriating events, modelling them, and making them salable. It also provides a framework for digesting complex matters into simplistic images. Instead of the unprocessed, ugly truth, newspapers

and its technical aspects. Instead of a vertical hanging, he opted for a more monumental, horizontal one and an intensified monochrome saturation. From a distance, they resemble color field paintings. Yet these works contain a subtle play of light that subvert the viewer's expectations. Those who look carefully discover close-up pictures of recent political and social events. Recognizable, widely circulated photographs seep through the field of blue. There's the picture of the public attending Obama's farewell speech in *Memento* (*Farewell, Blue*) (2019)— the largest of the series—or *Detestable Act* (2019), Van der Auwera's most iconographically Christian and sensually charged composition, capturing an intimate embrace between a boy and a girl amid a crowd following the school shooting in Parkland, Florida. Its details are revealed or obscured depending on the time of day, lighting, and position

REPRESENTATIONS OF FUTURE MEMORIES

stage a ceremonial representation. The pictures presented use a visual language, a hyper-coded schema intended to turn "trivial" images into "weighty" impressions. This system is tailored to the audience: we prefer a daily suspension of disbelief to the intrinsically perverted nature of so-called reality.

Van der Auwera's blue-out, like cinematography's blackout, isn't just a means to represent the unrepresentable. It is also a technique to appeal to the imagination that puts the tragic and sublime on the same plane. His images gnaw away at us with the lingering reminder of a simple, yet often unstated, truth: the fact that we don't see something doesn't mean it isn't there.

After realizing the first twelve of his "Memento" works, Van der Auwera began delving deeper into the image building process

of the viewer. It is probably no coincidence that the image is best disclosed when the viewer is knelt before it.

In *Farewell Blue, Detestable Act,* or *Nuit Américaine* (2018), Van der Auwera no longer covers parts of the panel. Instead, he excerpts an image and blows it up, spreading it across the frame. While the vertical works combined two offset plates, more recent ones vary between one, two, four, or six panels. Van der Auwera pushes his analysis of news media mise-en-scènes one step further by orchestrating his own news page, his own article, his own piece of fake news. In *Detestable Act*, he usurps and reassembles words and images from different sources. This strategy arose, in part, from scarcity. While in 2016–17 the media was still flooded with catastrophic images, newspapers are no longer willing to waste entire— let alone multiple—spreads on this kind

of material. Social media has taken over, shifting the onus from professional photographers to any person in the street wielding a camera phone.[3]

Van der Auwera's reconstruction of a journalistic look and feel, which appropriates the jargon and constructed reality proper to photojournalism, confronts the audience with a formidable challenge. The artist holds up a mirror to us, the conditioned viewer. Can we still grasp the complexity of these images in our over-mediatized daily lives? When faced with this difficult task, most of us, even without realizing it, fall short. As Marie-José Mondzain writes,

> We have become accustomed to call media-friendly all that speaks to a public via a channel and we infer that everything can be channeled. But images can't be channeled. Images

At times, the works are interrupted by vertical lines or strokes, as if undergoing a fast-paced treatment by a dysfunctional machine. Instead of painting with light, as with his blue works, here Van der Auwera applies paint by proxy. *Memento (Farewell, Red)* (2019) is a perfect example. Both horizontal and vertical lines crisscross the plane, as if the paper had been previously folded. Like its antecedents, this work too conceals a staged and choreographed grief.

A juicy anecdote lies behind the name "Memento." On one of the first cardboard packages he received from the printer to protect his early panels, Van der Auwera noticed what he thought was the word "memento" written with ball-point pen. He assumed this was printing jargon to indicate that the raw material was print-ready, but he was mistaken. At the time, *La Libre Belgique*'s printing press was also being used to publish

A CERTAIN AMOUNT OF CLARITY

greatly surpass channels and with their ruses invade bodies and minds that our channel programmers think they control.[4]

For his third and (at the time of publication) final iteration of the "Memento" series (2018–19) Van der Auwera adds yet another element of elaboration. In addition to the familiar cyan, he puts leftover ink back onto the rotary press and passes the plate through several times. This generates a varied palette of bright and deep reds, blues, purples, and blacks that echo the series' origins in *First without words*.

a weekly lifestyle supplement called *Momento*. Van der Auwera nevertheless chose to keep the name, which has proven prescient. These works testify not only to events but also to a process and format that will likely become a mere memory in the not too distant future.

going viral through social media today will no longer exist in a couple of weeks, with the exception of Twitter's black boxes, Facebook's stagnating posts, or Instagram's archived images. Van der Auwera acts as an archeologist of contemporary media, a savior or guardian, who recognizes the historical value of the images passing us by at ridiculous speeds on a daily basis. He borrows them, steals them, and even buys them

to isolate them in his video works or photo series, themselves black boxes in their own right.

4
Marie-José Mondzain, "Can Images Kill?" trans. Sally Shafto, *Critical Inquiry* 36, no.1 (Autumn 2009): 26–27, doi: 10.1086/606121.

121

122

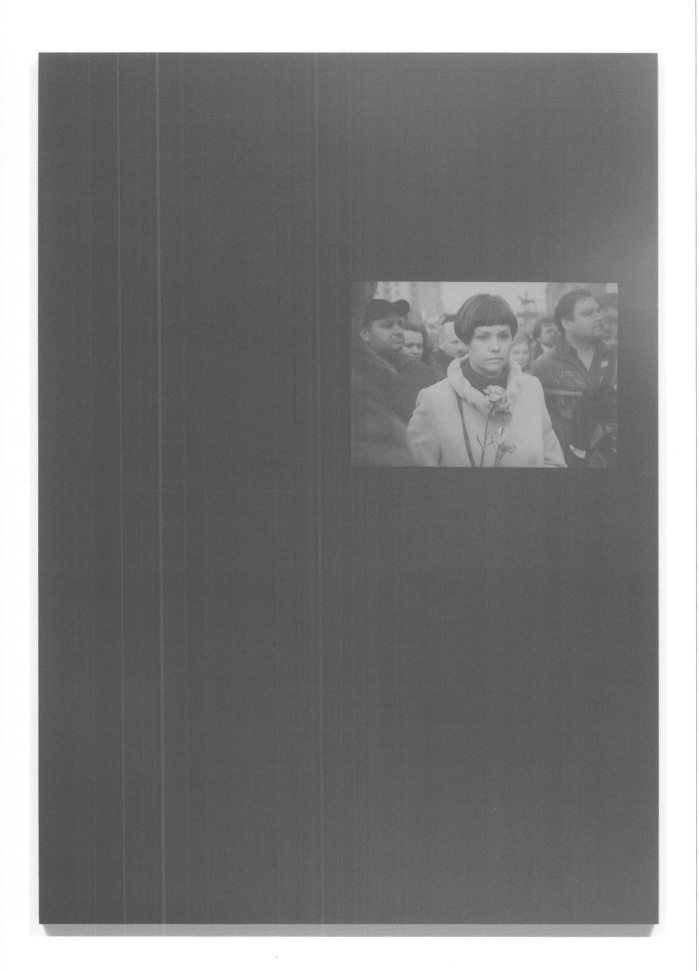

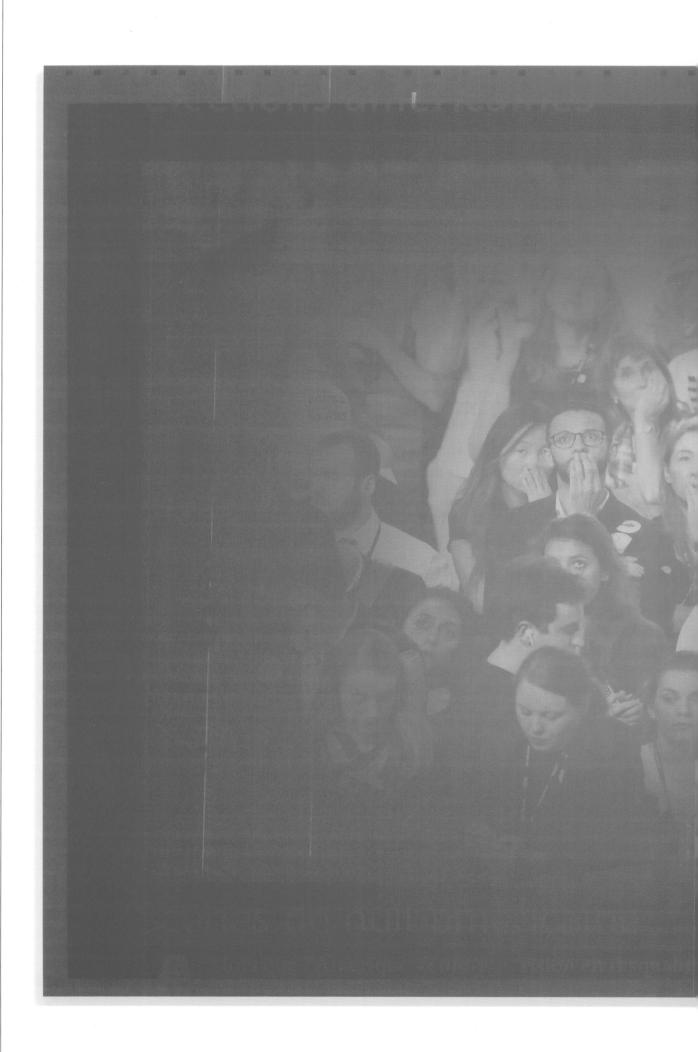

124

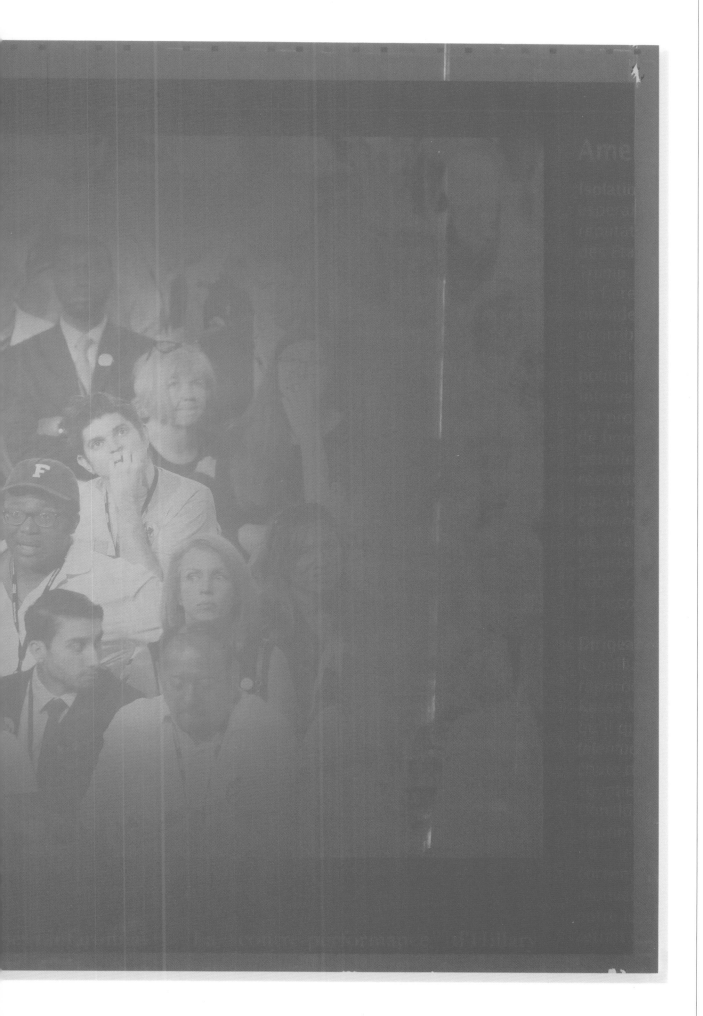

128

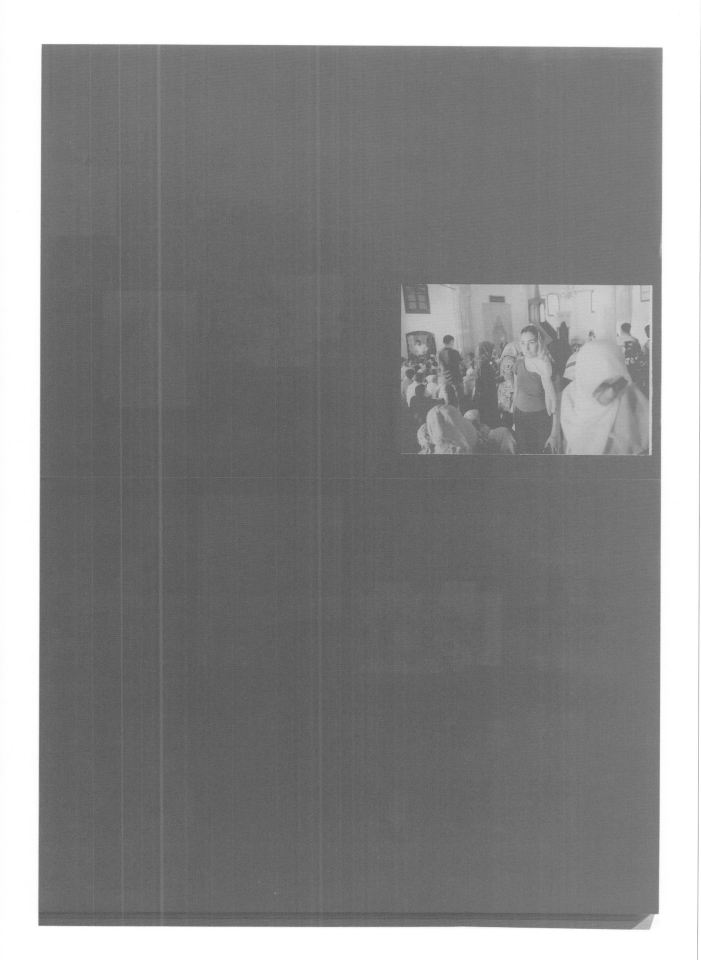

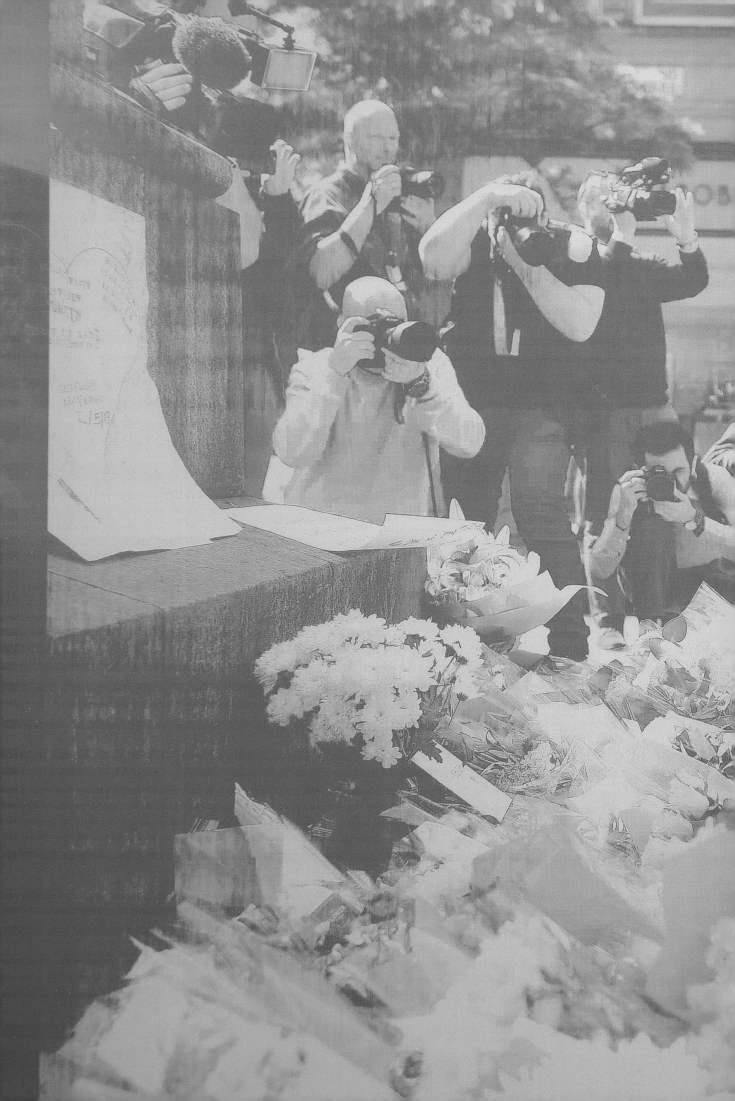

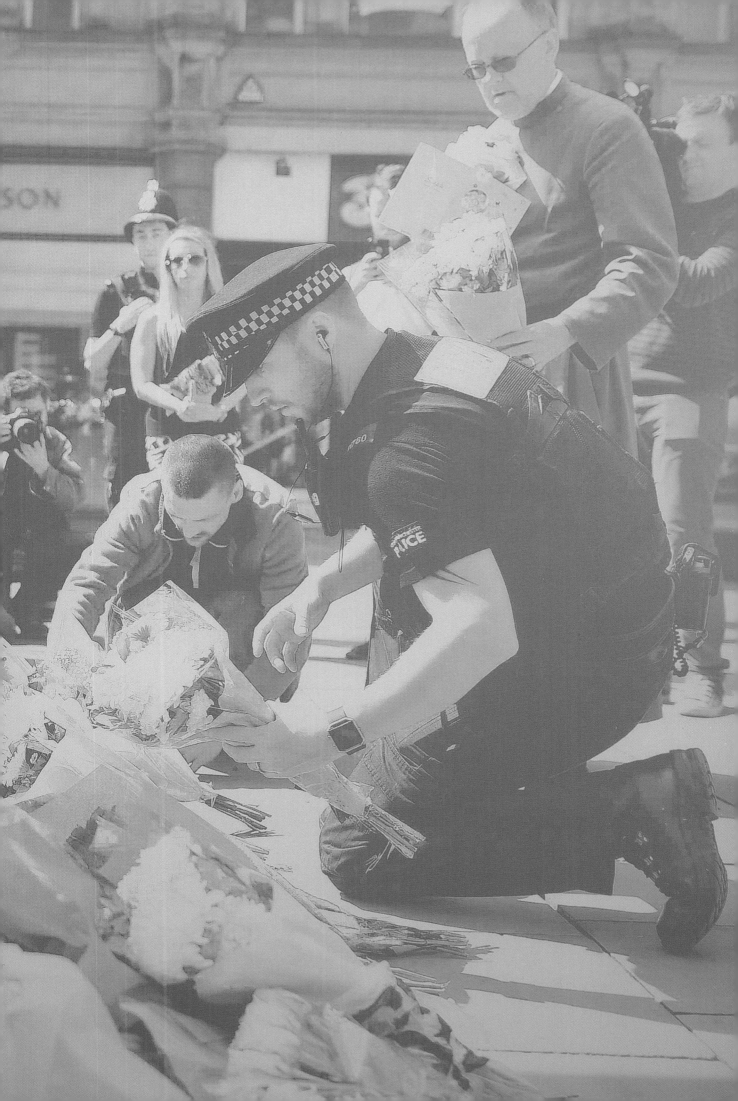

134

140

Students join 1,000 mourners at a Vigil Thursday at

A 'DETESTE

142

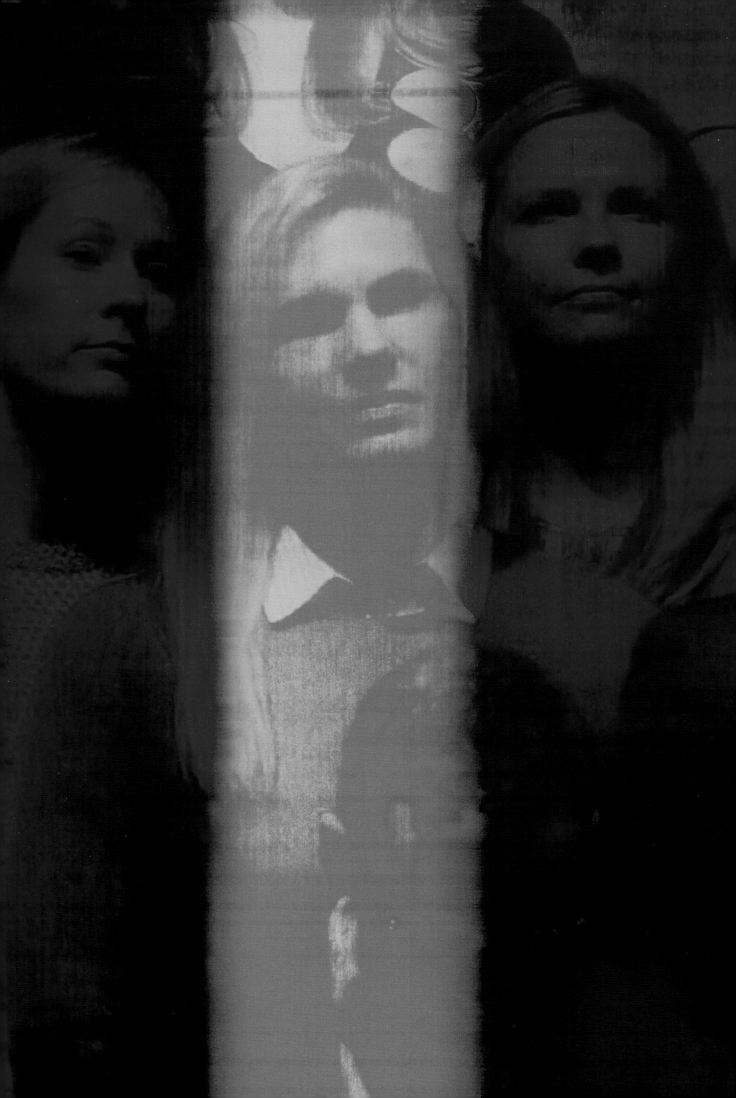

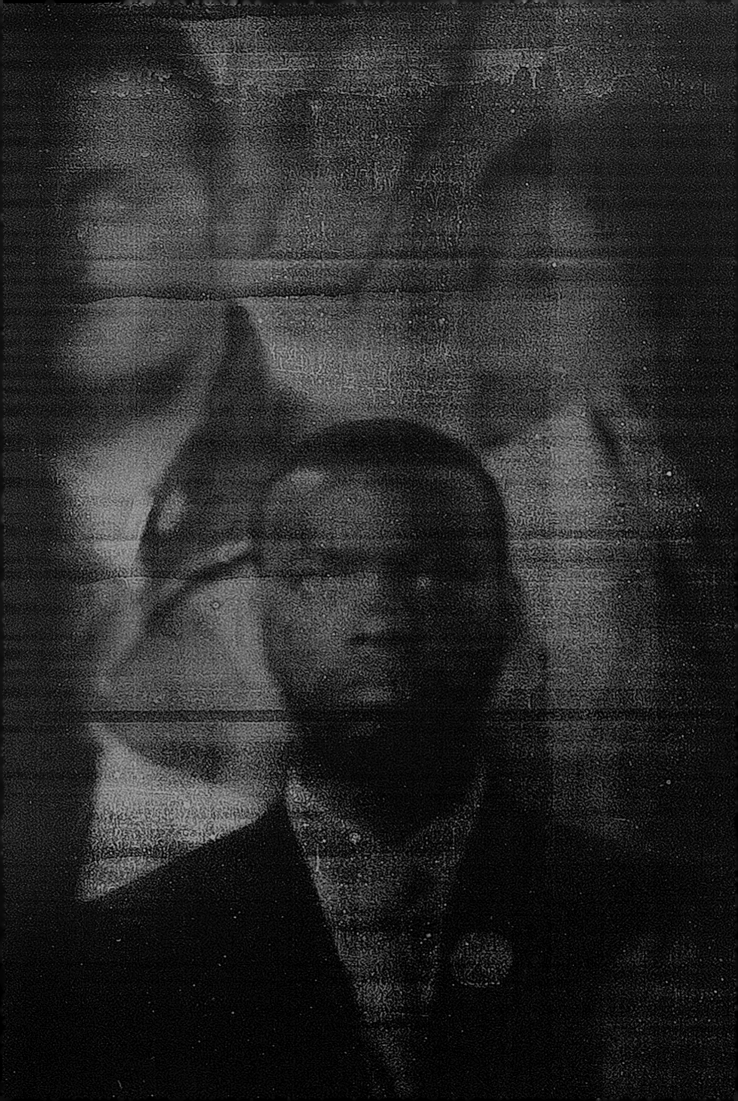

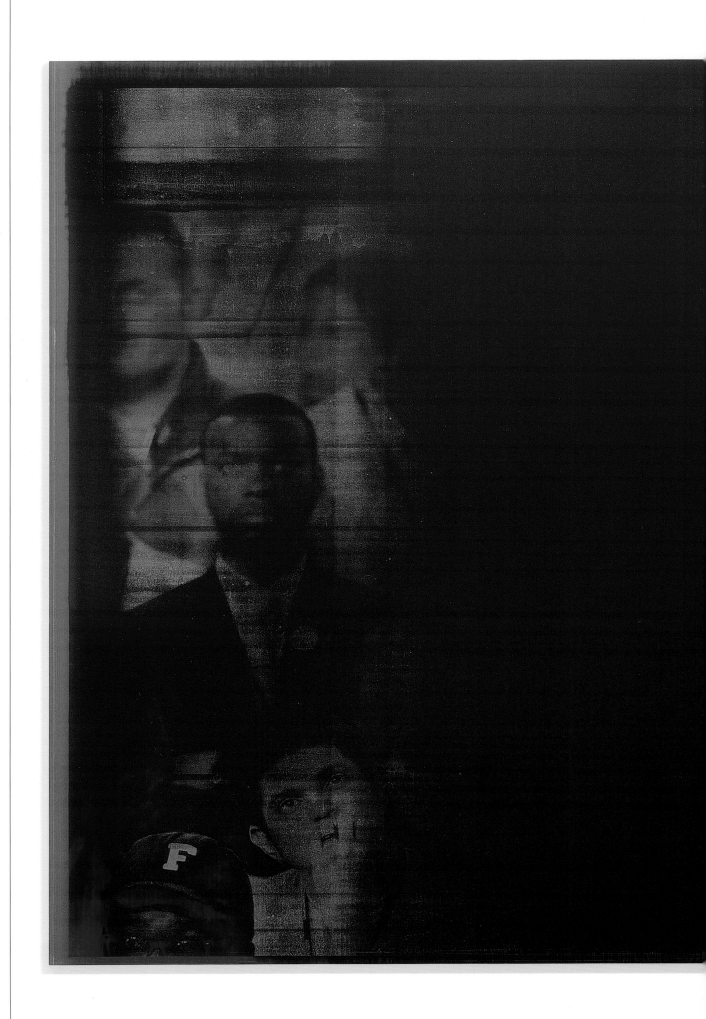

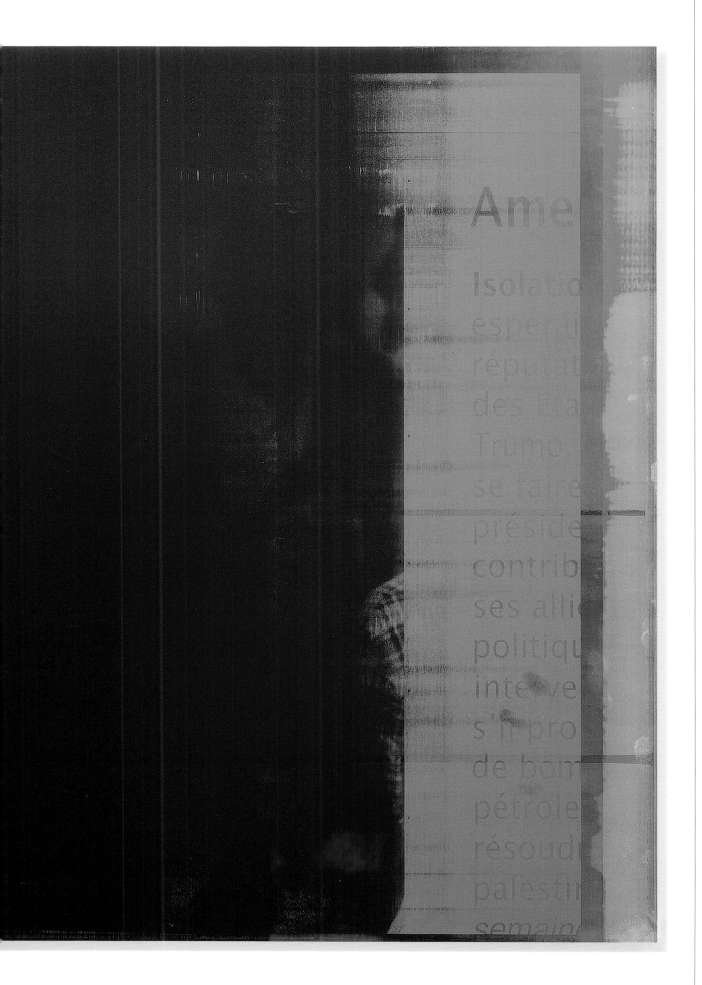

154

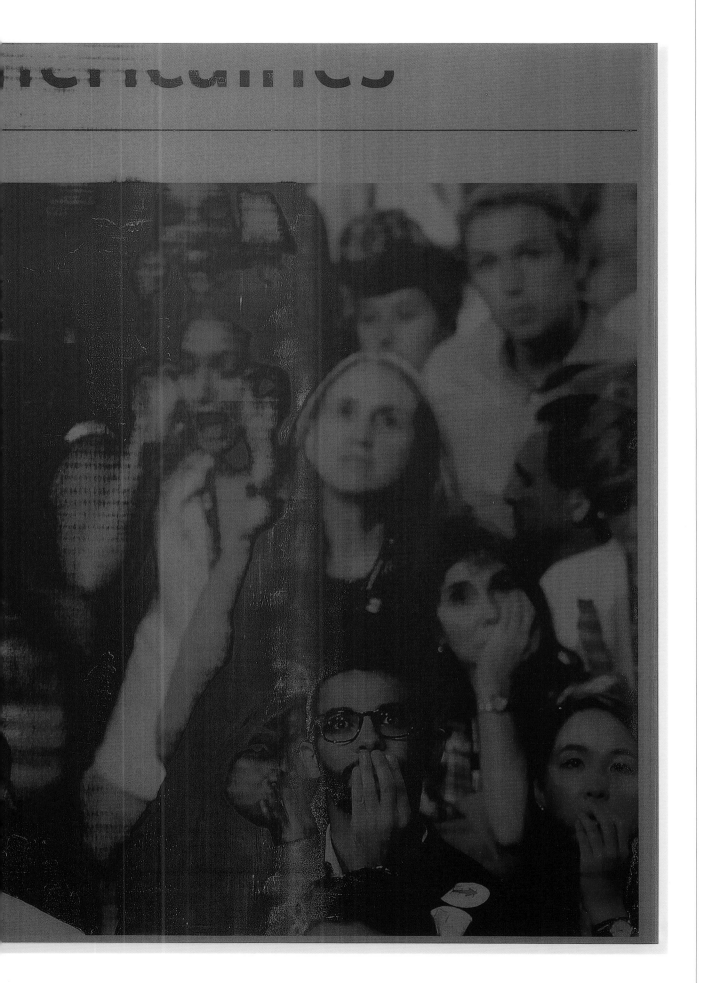

Memento 19 (Red V, Study for Nuit Américaine), 2018

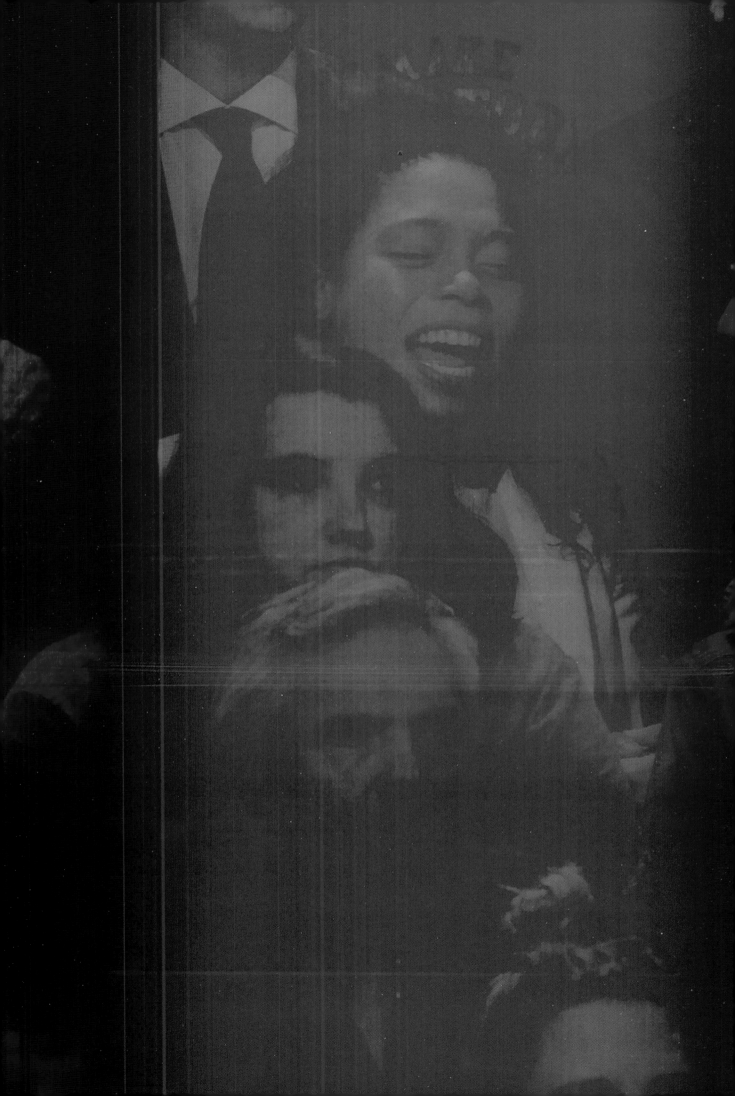

Memento 17 (Red IV, Study for Nuit Américaine), 2018

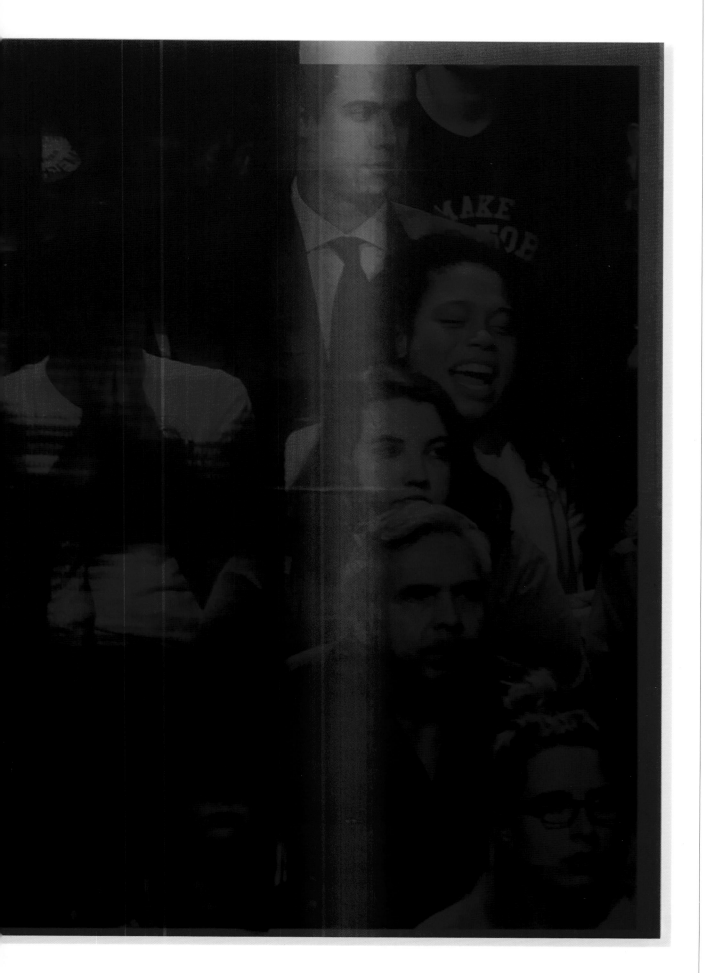

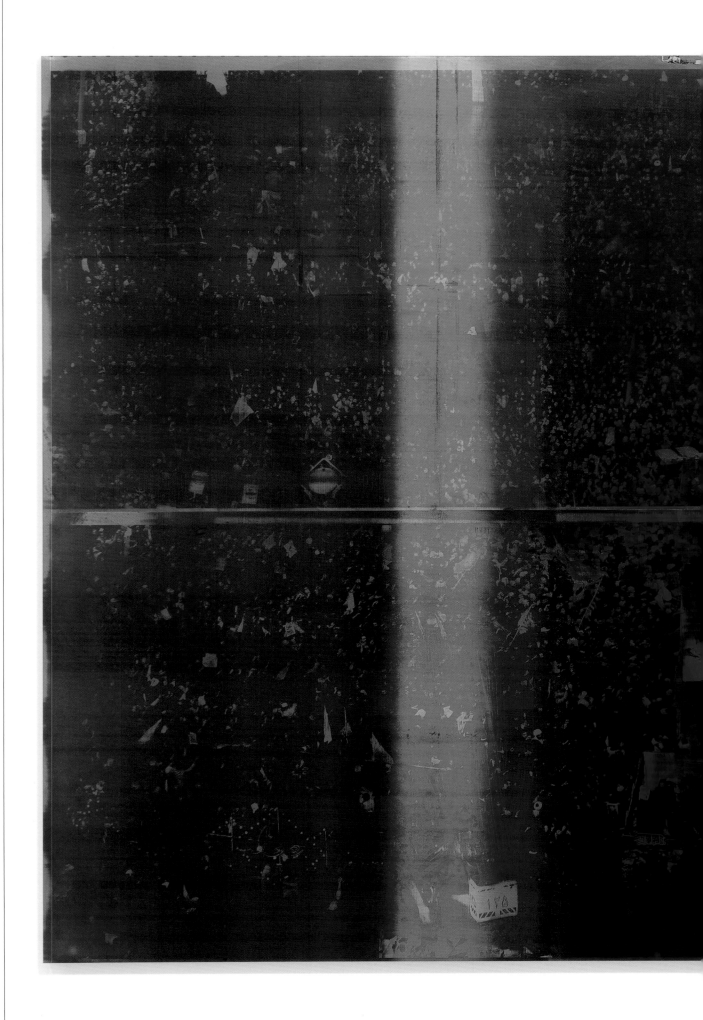

162

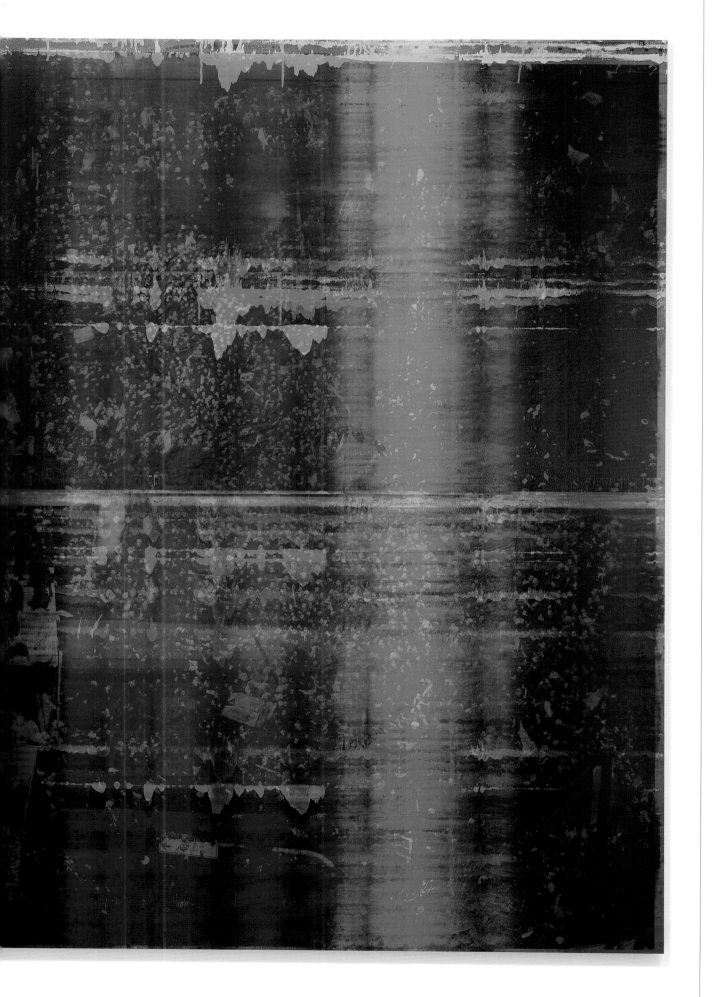

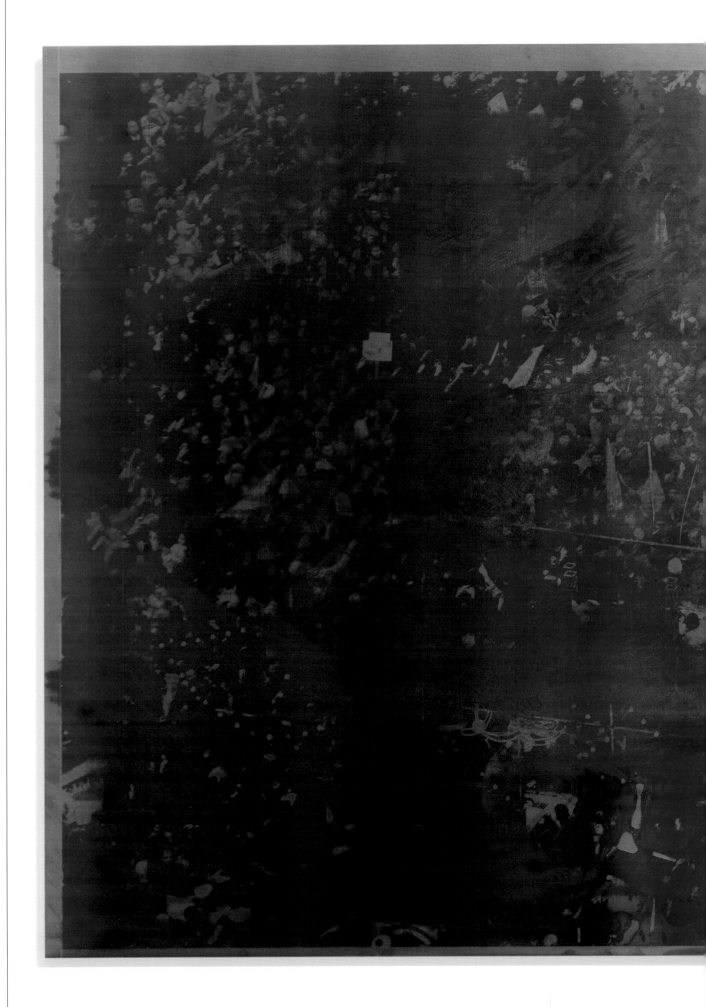

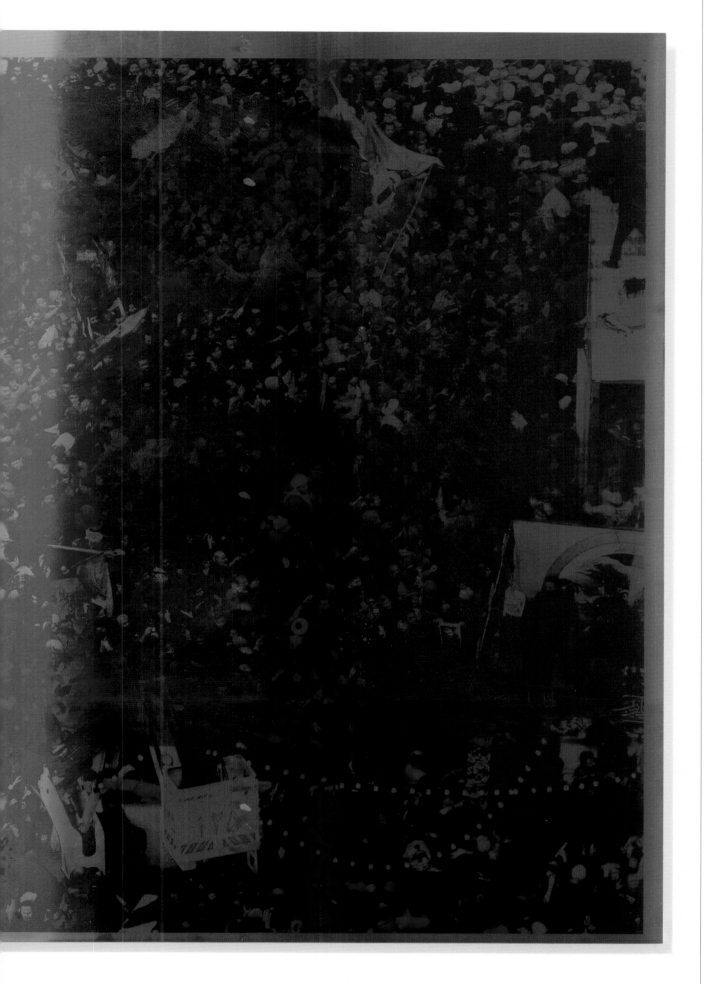

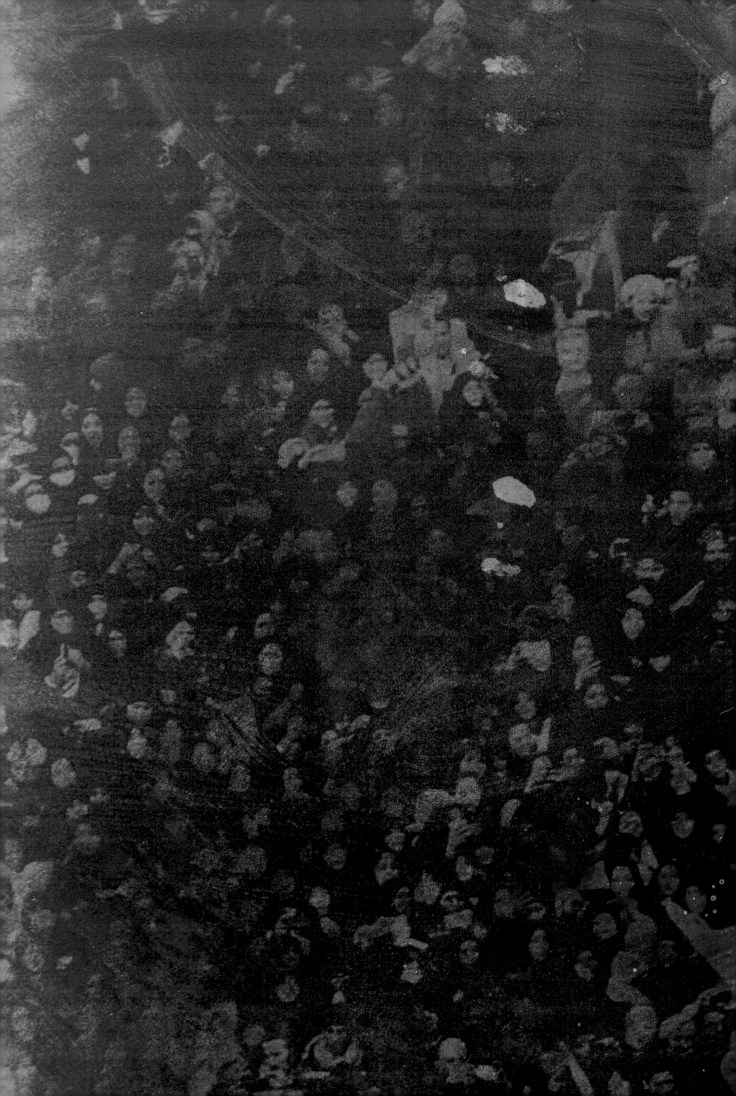

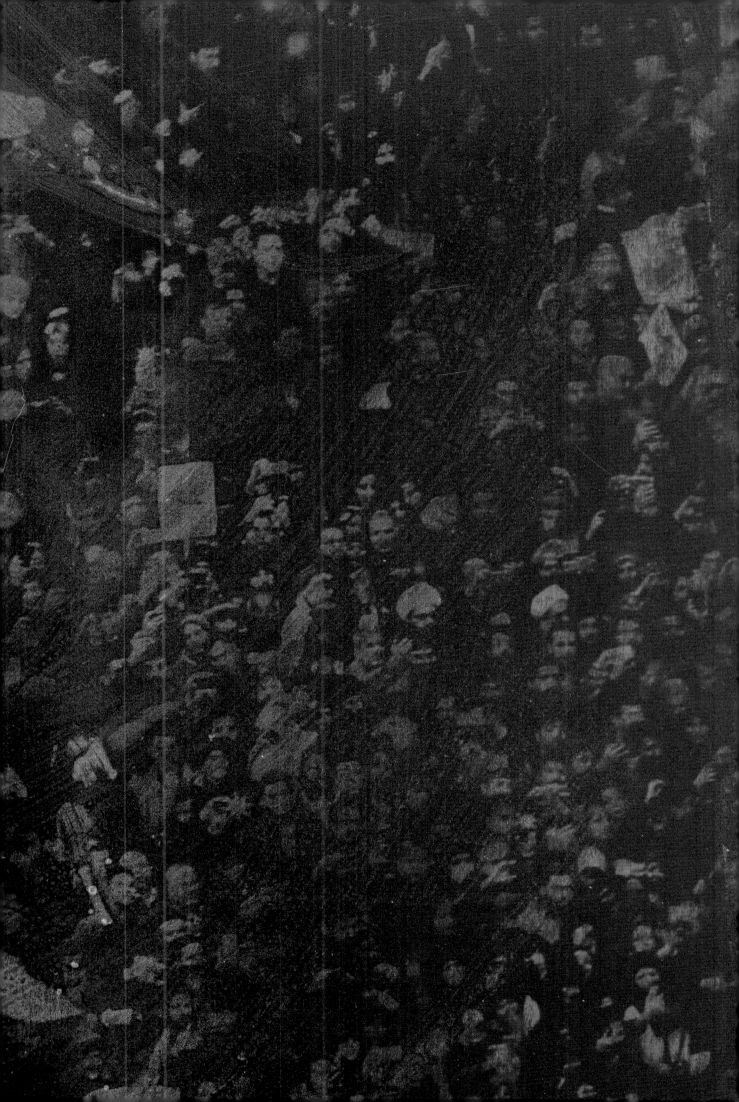

THE AESTHETICS OF CLARIFYING SOMETHING THAT RESEMBLES A BLACK HOLE

HANS MARIA DE WOLF

THE AESTHETICS OF CLARIFYING SOMETHING THAT RESEMBLES A BLACK HOLE

When, toward the end of their four-day-long colloquy, Marcel Duchamp asked Pierre Cabanne whether he had ever heard of the Viennese Circle, Cabanne replied, no. Duchamp explained that a group of mathematicians had developed a model that could reduce virtually everything to a tautology. All that exists, they argued, is merely a repetition of existing premises. I presume it was Duchamp's discovery of these debates (largely inspired by Ludwig Wittgenstein) that led him to declare that everything could be reduced to a tautology, "except black coffee!"[1] When one looks into a cup of coffee, logical empiricism gives way to one's senses.

Around this time, in 1960, the amateur Duchamp translator, scholar, artist, and pedagogue Serge Stauffer also passed some time in Duchamp's company. Stauffer later penned an emotional tribute of the encounter titled,

"Du coq à l'âne mit Marcel Duchamp."[2] From that record, one line is of particular interest to us: when Duchamp explains to Stauffer that, frankly, he cannot understand why artists aren't more exacting in determining the spot from which their artwork should be viewed. Unbeknownst to Stauffer, Duchamp had been spending the last two decades working in secret to fabricate a diorama. Known as *Etant Donnés: 1° la chute d'eau, 2° le gaz d'éclairage*, it was only in 1969, one year after his death, that the artwork was revealed, sending even Duchamp's devotees into an uproar. To this day, the installation's suggestion of brutality and rape is difficult to reconcile.[3] Crucially, the only way to view the graphic scene is while peeping through two holes, drilled by the artist in an old Catalan stable door.

From this Duchampian lore I propose distilling several concepts—those of tautology; the position of the

spectator in regard to the work of art; the placement of the artwork in regard to the art world; and what I call a negative dialectics engendered by the artist through the artwork—in order to take a fresh look at one of the most surprising presentations in contemporary art today: Emmanuel Van der Auwera's "VideoSculptures" (2015–present).

Video sculptures are produced by the physical act of sculpting. Flat screens are thin, rectangular light boxes. The appearance of moving pictures is made possible by a filter glued to the light box's surface. When Van der Auwera began making video sculptures, he expanded the basic principle in a sensational new direction. After separating the filter and the light box—possible only through the painstaking process of manually slicing it off—the artist had at his disposal a number of elements that he could begin to interconnect in a completely new way.

These collages part a forbidden curtain. Flat screens today are shaped as if perfect, thin, black marble plates. The summit of their essence is the absence of even an on/off-button. In destroying their protective filters, the artist exposes technology's feigned self-effacement to reveal a fabricated illusion.

Soon after, Van der Auwera tilted the potential of his "VideoSculptures" on another plane. He freed the filters from their screens entirely, thus carving a path toward more direct dialogue with the spectator. *VideoSculpture XIV (Shudder)* (2017) comprises four flat screens installed on a wall with a thin, glass plate placed delicately on the ground before it. Though images play across the four screens, they are visible only on the glass, which replaces the filter as a polarizing agent.

A CERTAIN AMOUNT OF CLARITY

Early on, Van der Auwera would strip off pieces of filter while keeping other parts intact, resulting in a mesmer-izing visual duality. Partially destroying the filter created optical inversions, such as shifting from a positive to a negative image, while turning the "liberated" filter in another direction changed its color balance, so that new ones appeared. For those who think that the medium of collage is confined to paper alone and embedded in Modernism, Van der Auwera's torn video screen filters are a persuasive counterexample.

In 2018 *Shudder* was displayed at KANAL — Centre Pompidou in Brussels as part of the exhibition *Kanal Brut*. There, it was placed at the end of a relatively long, rectangular room. Upon entering, visitors were confronted with the screens' white glow on the far wall. Two intersecting black lines formed a cross where the four screens were joined together. The dark glass plate was raised slightly above ground level, as if a floating, marble tombstone. To the naked eye, the screens yielded nothing but a blank stare. Only when looking down into the dark glass could one see images flitting by, seemingly ad

1
Pierre Cabanne, *Dialogues with Marcel Duchamp*, trans. Ron Padgett (New York: Da Capo Press, 1971), 107.

2
Marcel Duchamp, "Du coq à l'âne mit Marcel Duchamp," *Die Schriften*, trans. and ed. Serge Stauffer, vol. 1, *Zu Lebzeiten veröffentlichte Texte* (Zurich: Regen-Bogen Verlag, 1981).

3
The installation's title derives from a note in the so-called Green Box, in which Duchamp collected 96 facsimile notes about the mechanisms of the *The Bride Stripped Bare by Her Bachelors, Even (The Green Box)* (1934).

infinitum, as if squinting into an external universe. The result was enchanting.

Each of *Shudder*'s brief, sound-less clips was acquired from a stock image site. Typing in keywords (as the artist did), such as "loneliness," "trauma," "distress," or "unhappy US marine," retrieved a selection from the immense database. Stock image sites, like the one Van der Auwera used, commercialize—in service of a vast advertising market—images that reproduce an intelligible experience of reality. They do so in an automatized way, submitted to powerful algorithms. What we obtain—and what *Shudder* reveals—is an aesthetics of "loneliness," of "trauma," and of the "unhappy US marine." It arrives packaged as a frostbitten, if perfectly tautological, alternative to reality.

In witnessing *Shudder*'s changing images, appearing as a film in negative, our comprehension of reality is temporarily

real life. Its surface is but a peephole to another state of light that makes visible what is imperceptible to the naked eye.

Shudder takes possession of the spectator's gaze. It drives us into profound confusion. As viewers, the best we can do is marvel before an alien experience. Not what we see but how we see is the crux of this relationship. What makes the work all the more convincing is its formal clarity, itself based on an aesthetic paradox. As light emits from the screen, its images pass through the ether to their resting place, the glass. The work resides nowhere, on neither screen nor glass. Rather the ether becomes both its conduit and the site of realization.

If *Shudder* places images in the figurative depths of a black marble tombstone, *Videosculpture XX* (*The World's 6th Sense*) (2019) disperses

THE AESTHETICS OF CLARIFYING SOMETHING THAT RESEMBLES A BLACK HOLE

overruled by an alternative impression of existence. In that moment, we ignore all laws, rules, and finalities. Our consciousness is split and submitted to the eventuality of a preexisting form of energy. All that we call reality is perhaps only a reflection. The *VideoSculpture*, by its very materiality, stresses the unavoidability of its tautology. This—as far as my knowledge reaches—for the first time and in such a powerful way, since Duchamp's notorious *Etant Donnés* with which we began this essay.

Unlike the reflection of natural light off a cup at sunset (as observed by Junichiro Tanazaki in his novel *In Praise of Shadows*) or off the lacquered lid of a grand piano, *Shudder*'s glass plate mirrors nothing of its immediate surroundings. In fact, the dark glass of *Shudder* isn't a mirror at all, but a reflection of the glowing, white screen and its stream of images mimicking

them over ten tripods. Distributed across a room, each supports a small rectangular panel reflecting fragments of visuals engendered by blank screens hanging on the walls. Visitors are compelled to wander through the splintered images, which together suggest the possibility of a narrative that is never fully disclosed.

The visitor is now adrift, lost in translation, in an atmosphere pregnant with rumor and devoid of certainty, with whispers overtaking thoughts and snippets replacing the whole. The installation offers bits and pieces of information, again seemingly at random. Spectators—in their obstinate desire to understand—receive little more than visual clues.

Unknown to either the viewers or their filmed subjects, the reflected fragments are thermal images of pedestrians on the streets of Las Vegas, shot by a

private enterprise using a military-grade camera for promotional purposes. Though the people continue blissfully unaware, using highly performative devices to spy from this dangerously low altitude lends an air of paranoia and potential madness. This is a madness not only of overheated and over-armed individuals but of a system having accumulated previously inconceivable destructive capacities that continue to grow, abetted by lobbyists. I am, of course, alluding to the US military complex.

As we navigate the installation's tripods, watching footage of unsuspecting subjects, we become both like them and complicit in their unconsented observation. That these pictures were produced with cutting-edge technology whose use is, in part, to protect borders at night—cameras which perceive migrants as nothing more than alien subjects who will eventually betray themselves by noth-

fan of Hegel. However, I take the liberty of irreverently borrowing his term. I use negative dialectics to describe a situation in which an artist produces an artwork that he or she knows will remain misunderstood, or not understood, for a long time.

When *Etant Donnés* was revealed to the public at the Philadelphia Museum of Art in 1969, after a long and grueling installation led by Anne d'Harnoncourt and Walter Hopps, it left Duchamp's close circle of friends aghast. It would take one of the best readers of Duchamp, the French photographer Jean Suquet, nearly forty years to accept the work as belonging to the artist's oeuvre. That Duchamp only left behind a few technical specifications added to the confusion. Moreover, Duchamp had requested that the museum forbid photography of the diorama's interior for fifteen years. I believe that Duchamp intended to

A CERTAIN AMOUNT OF CLARITY

ing other than their body temperatures—makes it all the more discomforting.

If we accept this reading of *The World's 6th Sense* as a multivalent source of experience and a new form of spatial consciousness, then we must also admit having reached a critical point of self-definition. In this work, the glass is both: representing and negating itself under the spell of the ether. The ether too is both: pretending to inform but lost in its own economic logics, echoing the shift from quality to quantity that marks mass communication and the propagation of communication technologies. It all coheres in the spectator's mind as she or he moves through the installation space.

I promised to come to terms with this superb piece of art, this theater of the human brain, by referring to Hegel's principle of negative dialectics. Like Duchamp, I am no

deliver a work of art that would operate, from the moment of its unveiling and for a long time thereafter, through the principle of negative dialectics.

So too Van der Auwera's "VideoSculptures." The dark glass and scattered tripods are our cup of black coffee, provoking sensations beyond our immediate, logical or tautological, apprehension. My readings of these works are thus only a first attempt to circumscribe a new and radical creation within the realm of contemporary art. A creation not only owing to Duchamp's legacy but leading us, as spectators, to unseen and unknown territories.

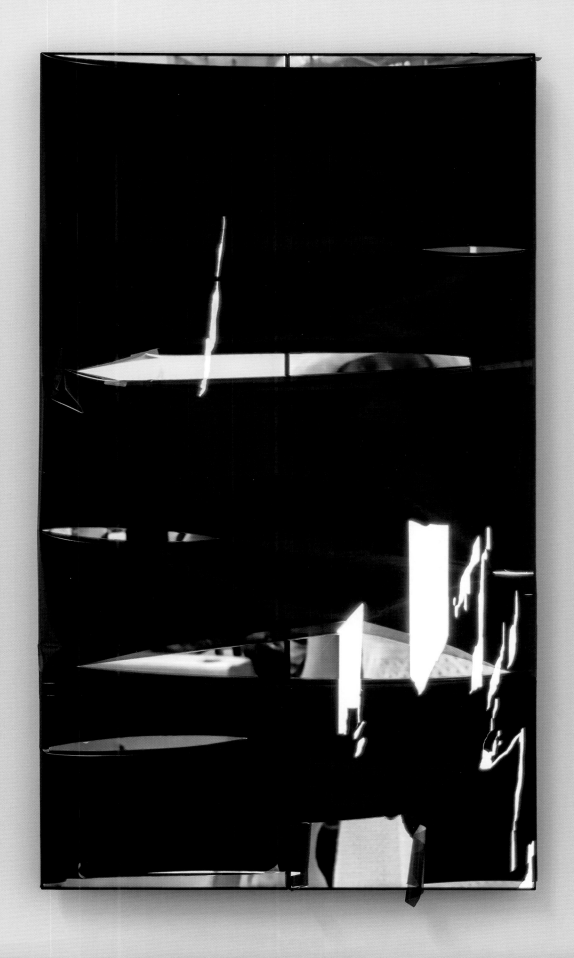

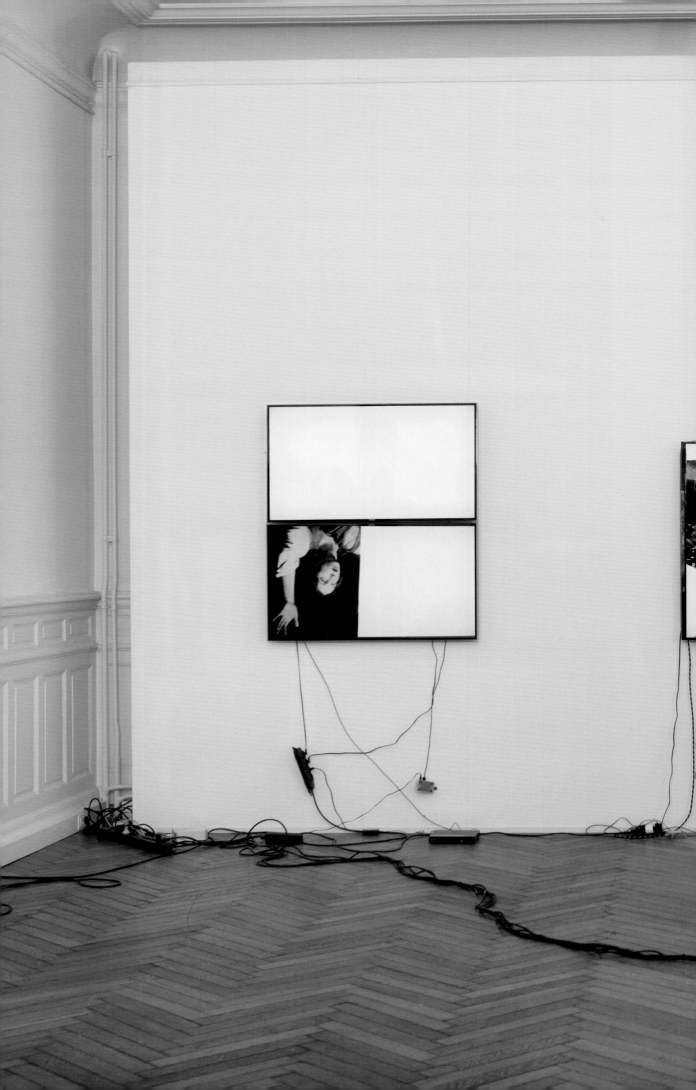

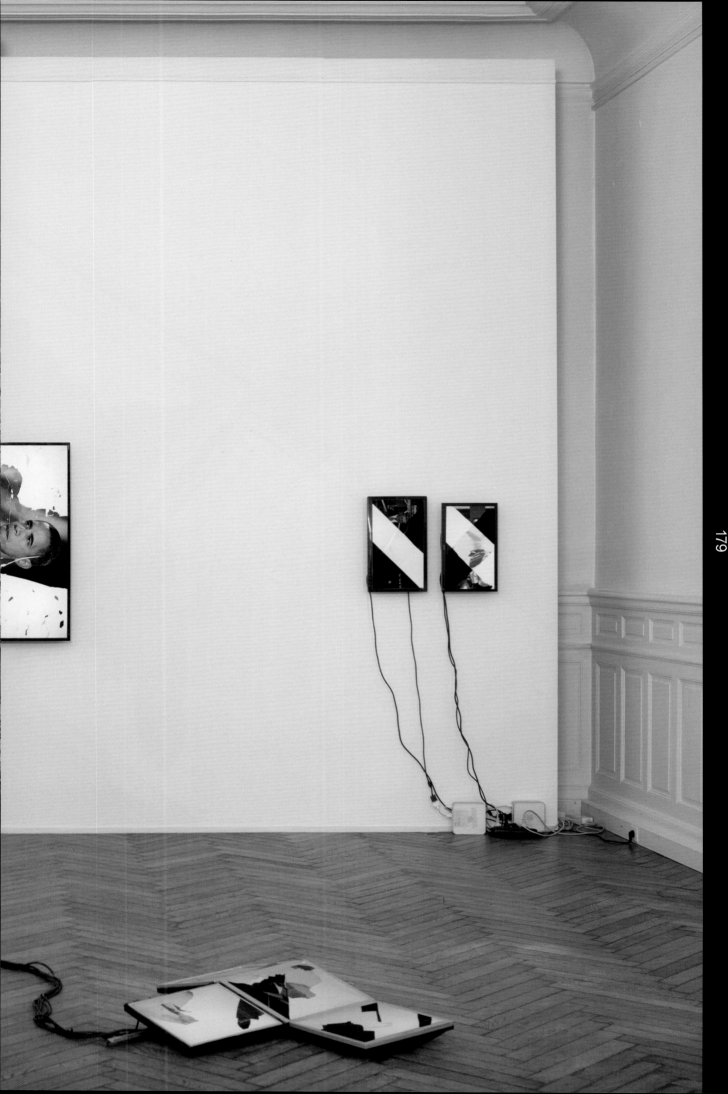

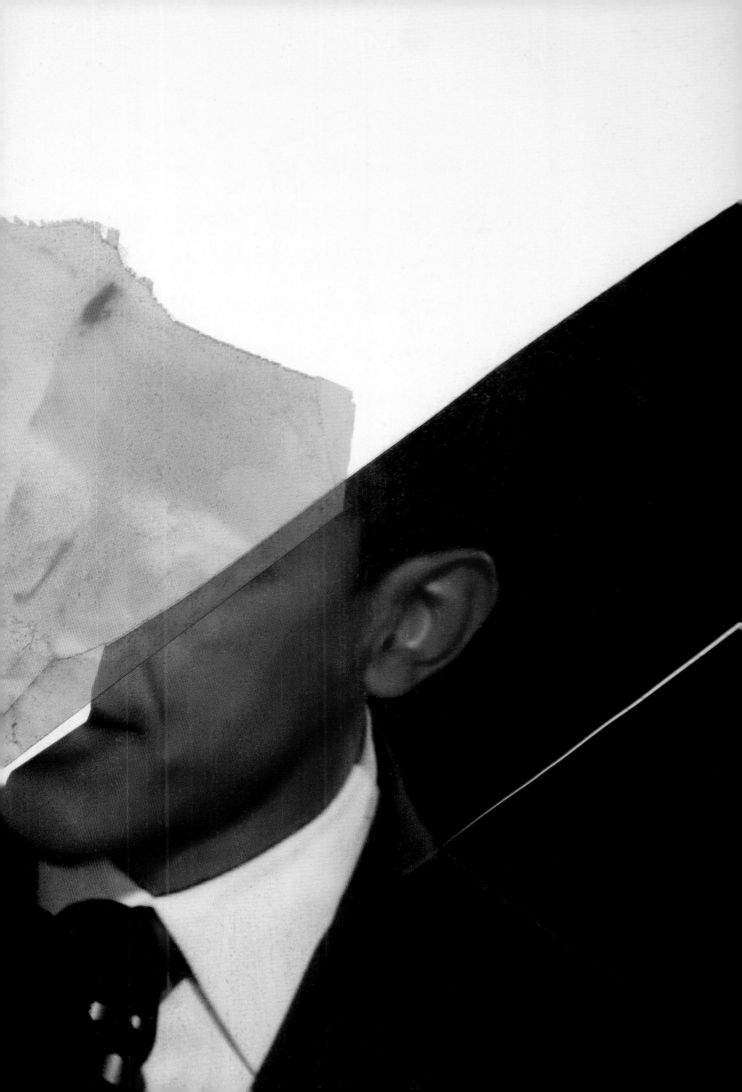

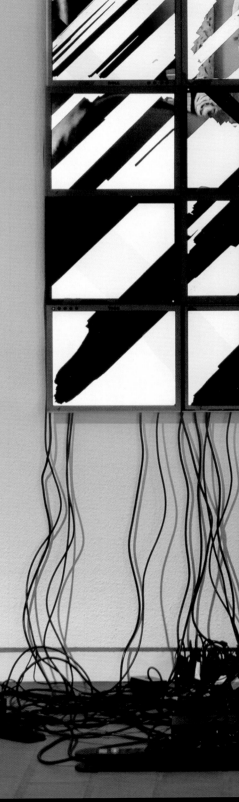

VideoSculpture XVII (O'Hara's on Cedar St.), installation view, *Blue Water White Death*, Mu.ZEE, Ostend, 2018

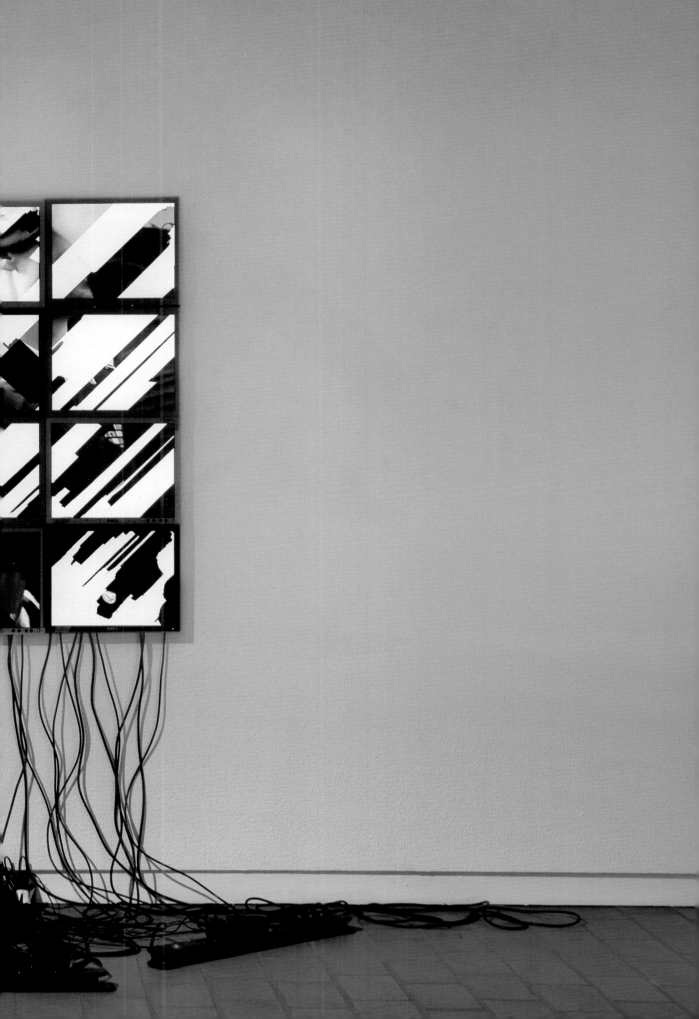

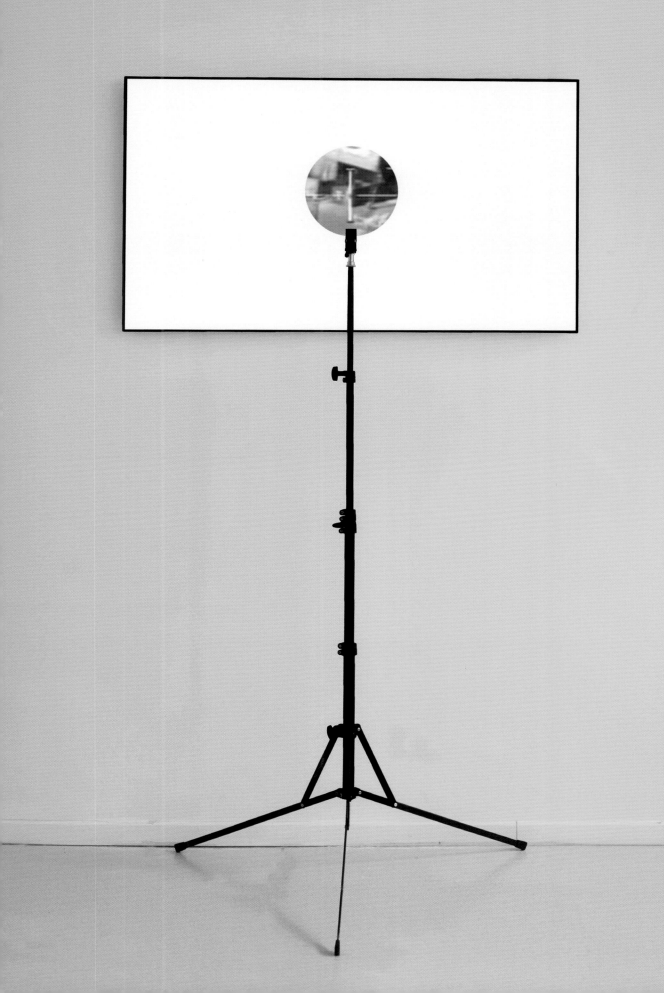

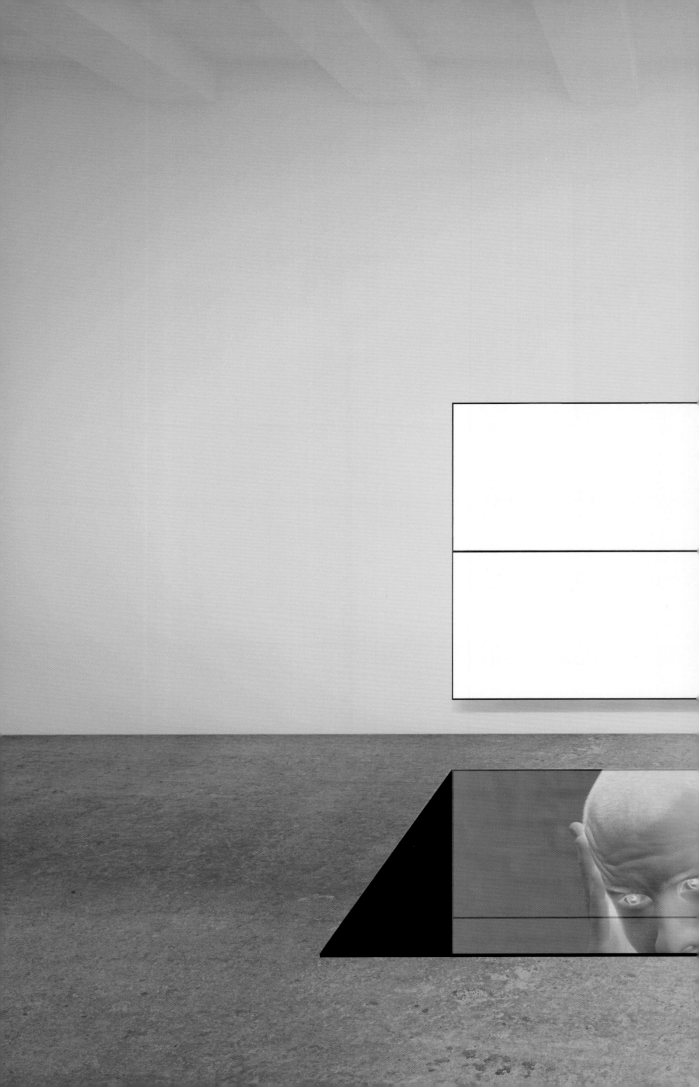

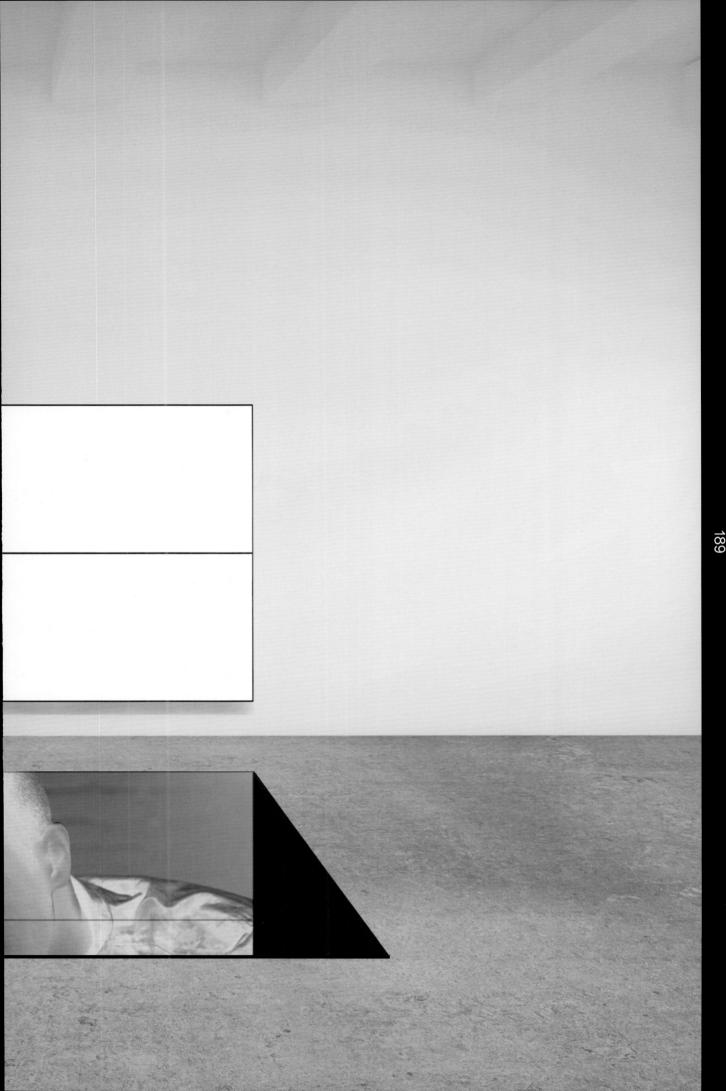

406

406

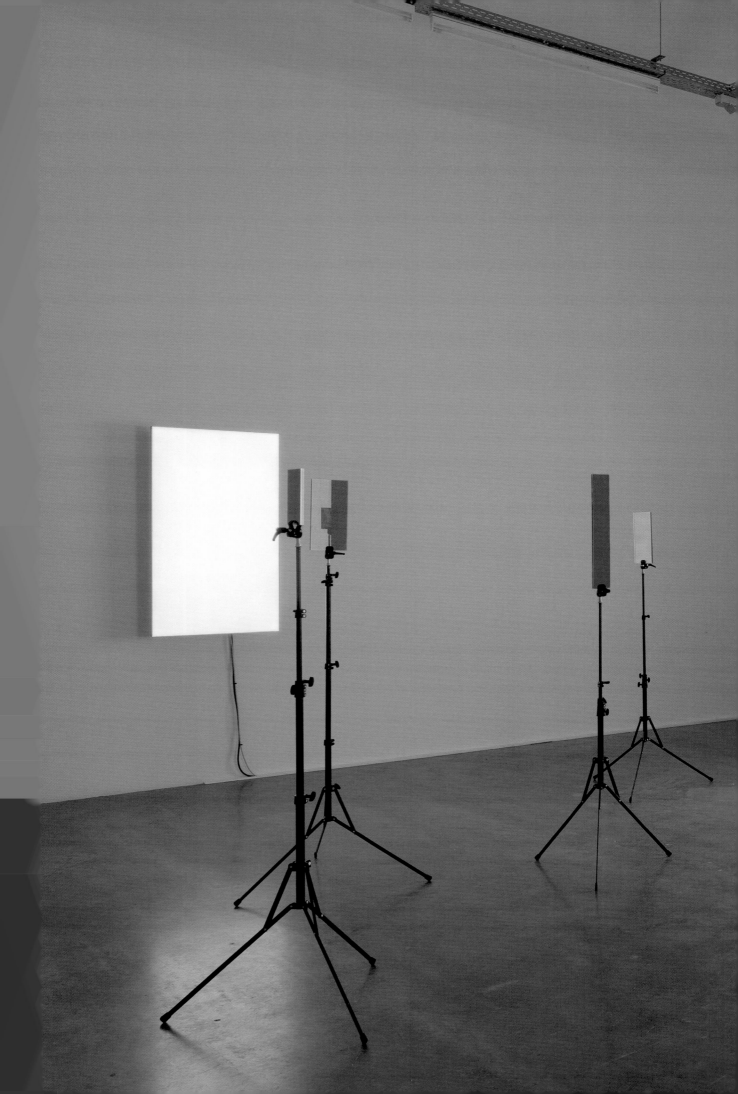

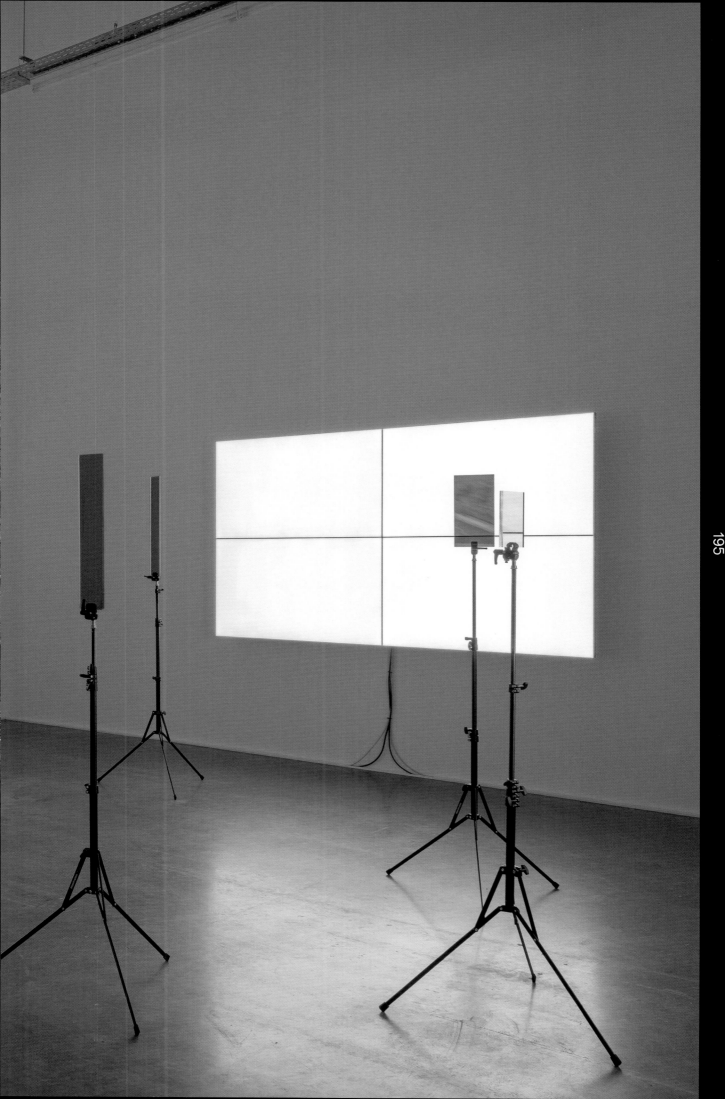

VideoSculpture XX (*The World's 6th Sense*) (detail), installation view, Harlan Levey Projects, solo presentation, Art Brussels, 2019

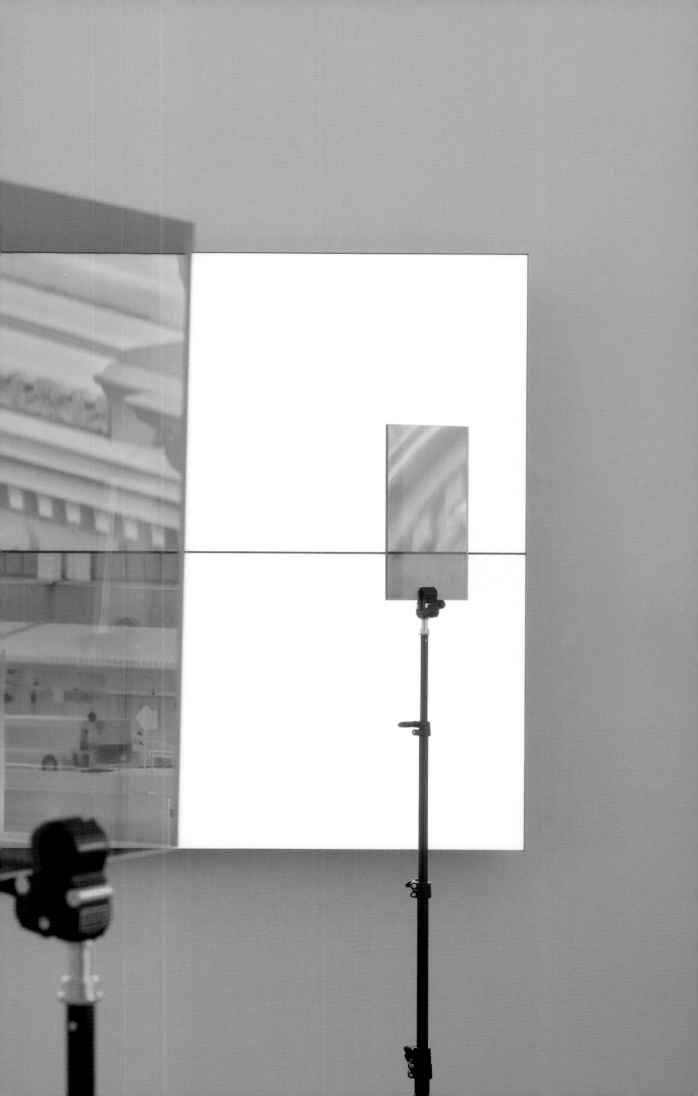

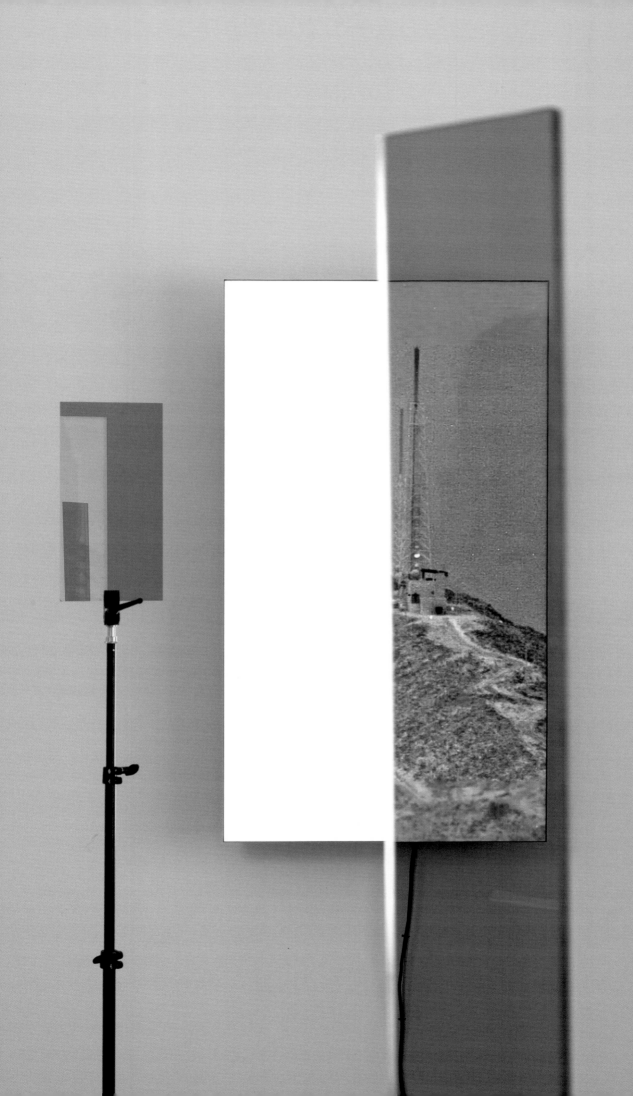

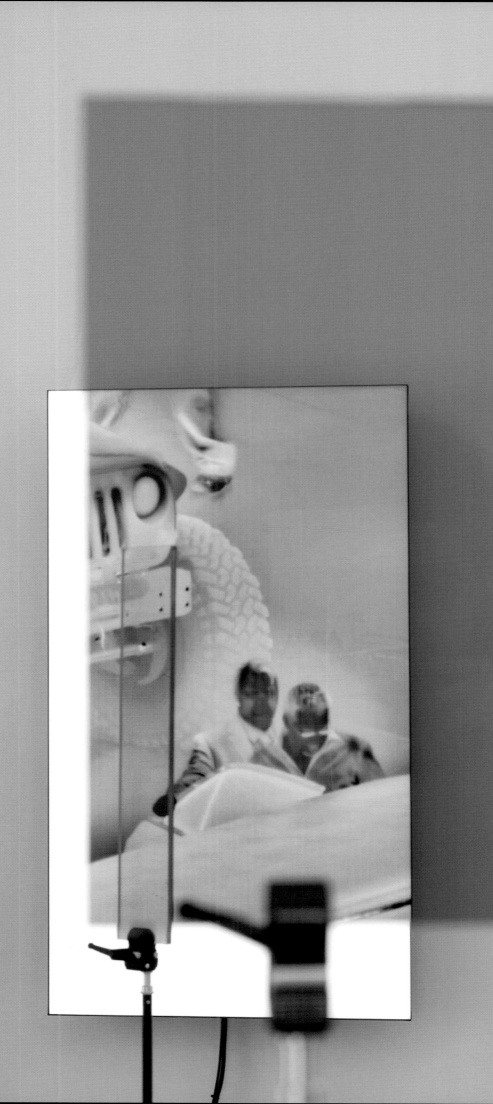

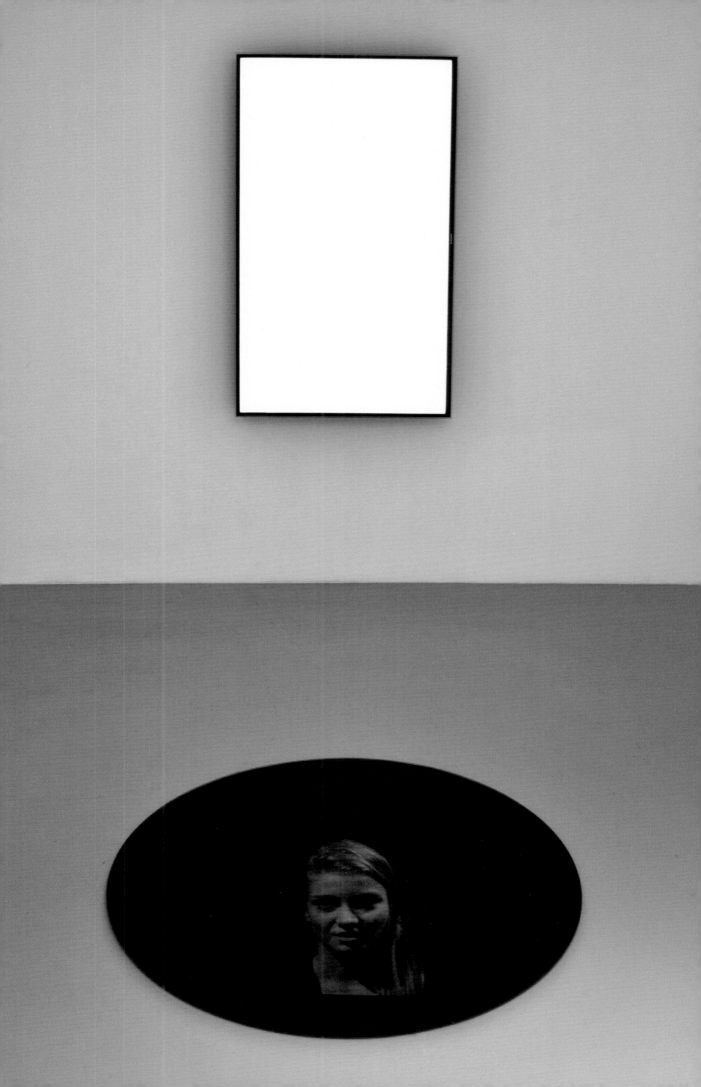

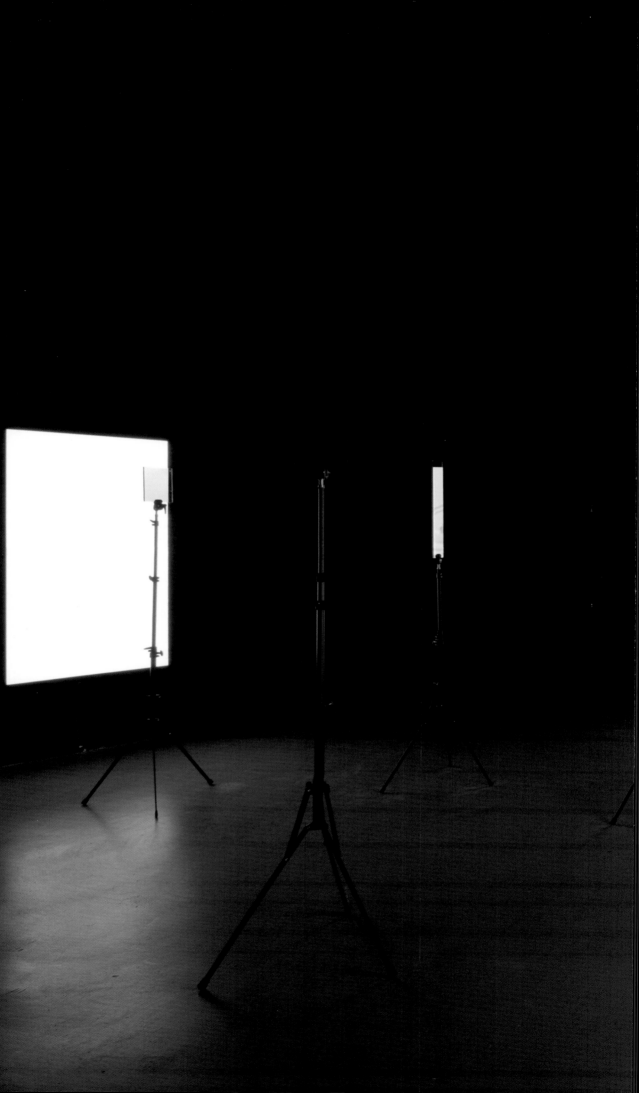

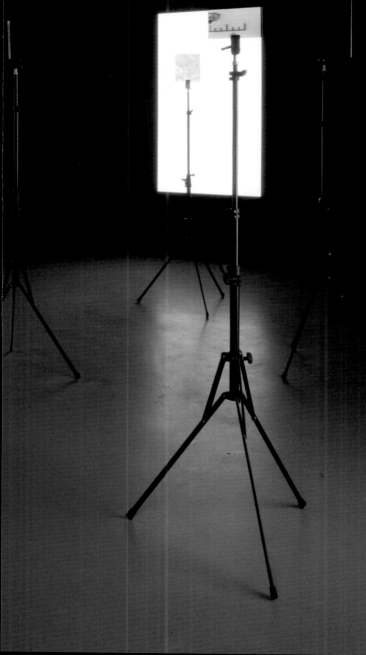

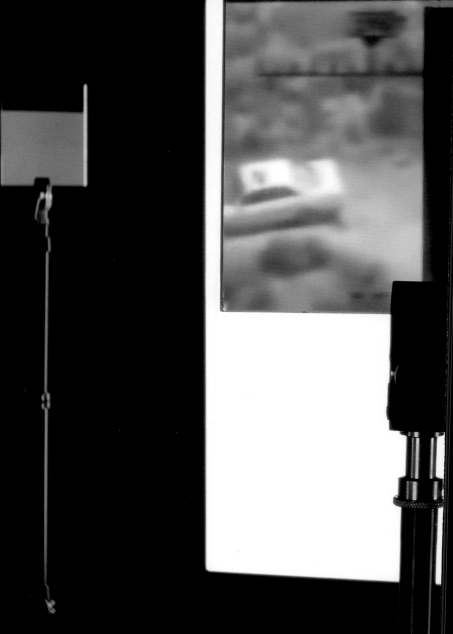

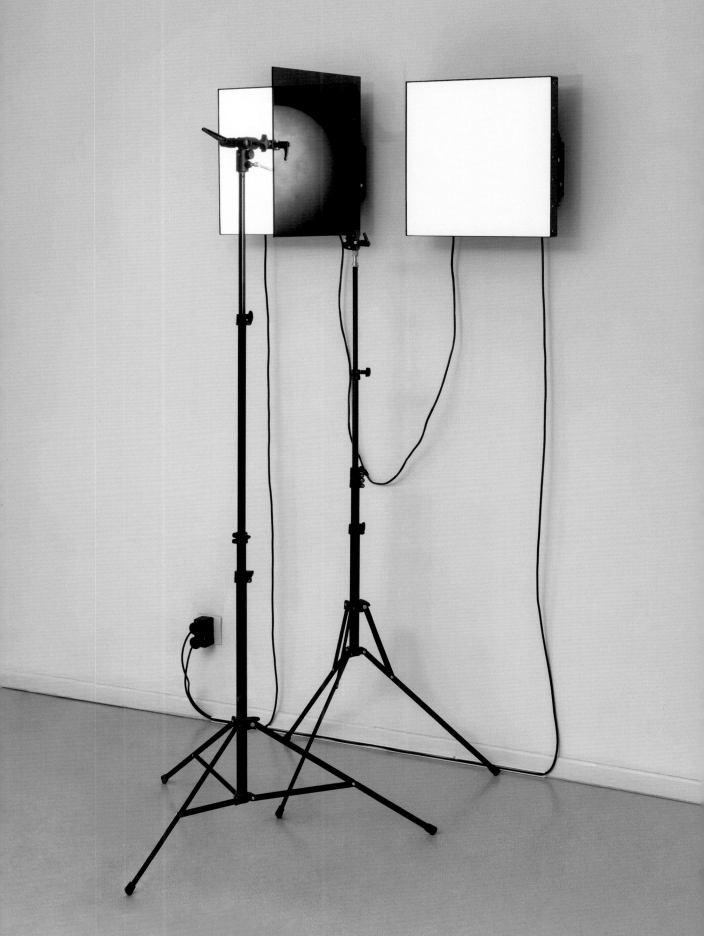

FILMS

MEMENTOS

VIDEOSCULPTURES

FILMS

A CERTAIN AMOUNT OF CLARITY, 2014
HD Video, 29 minutes 15 seconds

WAKE ME UP AT 4:20, 2017
HD Video, 12 minutes 22 seconds

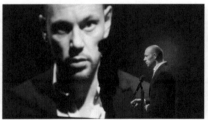

HOME, 2015
HD Video, 17 minutes 18 seconds

THE DEATH OF K9 CIGO, 2019
HD Video, 23 minutes 9 seconds

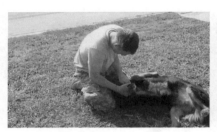

CENTRAL ALBERTA, 2016
Performance, 48 minutes

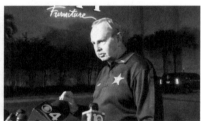

THE SKY IS ON FIRE, 2019
HD video, 15 minutes 21 seconds

CENTRAL ALBERTA, 2016
HD Video, 46 minutes 30 seconds

MISSING EYES, 2017
HD Video, 14 minutes 21 seconds

MEMENTOS

MEMENTO 1, 2016
Newspaper .3 mm aluminum offset plates
mounted on aluminum frame
143 x 99 x 2.5 cm — 56 1/4 x 39 x 1 in

MEMENTO 8, 2017
Newspaper .3 mm aluminum offset plates
mounted on aluminum frame
143 x 99 x 2.5 cm — 56 1/4 x 39 x 1 in

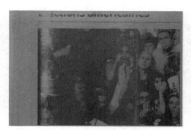

MEMENTO 16 (RED III), 2018
Newspaper .3 mm aluminum offset plates
mounted on aluminum frame
68 x 99 x 2.5 cm — 26 3/4 x 39 x 1 in

MEMENTO 2, 2016
Newspaper .3 mm aluminum offset plates
mounted on aluminum frame
143 x 99 x 2.5 cm — 56 1/4 x 39 x 1 in

MEMENTO 11, 2018
Newspaper .3 mm aluminum offset plates
mounted on aluminum frame
143 x 99 x 2.5 cm — 56 1/4 x 39 x 1 in

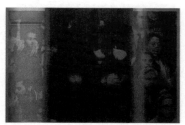

MEMENTO 17 (RED IV, STUDY FOR NUIT AMÉRICAINE), 2018
Newspaper .3 mm aluminum offset plate
mounted on aluminum frame
68 x 99 x 2.5 cm — 26 3/4 x 39 x 1 in

MEMENTO 4, 2016
Newspaper .3 mm aluminum offset plates
mounted on aluminum frame
143 x 99 x 2.5 cm — 56 1/4 x 39 x 1 in

MEMENTO 12, 2018
Newspaper .3 mm aluminum offset plates
mounted on aluminum frame
143 x 99 x 2.5 cm — 56 1/4 x 39 x 1 in

MEMENTO 18 (AMERICAN HORROR), 2018
Newspaper .3 mm aluminum offset plate
mounted on aluminum frame
68.5 x 99 x 2.5 cm — 27 x 39 x 1 in

MEMENTO 5, 2016
Newspaper .3 mm aluminum offset plates
mounted on aluminum frame
143 x 99 x 2.5 cm — 56 1/4 x 39 x 1 in

MEMENTO 14 (NUIT AMÉRICAINE), 2018
Newspaper .3 mm aluminum offset plates
mounted on aluminum frame
131 x 184 x 2.5 cm — 51 5/8 X 72 1/2 X 1 in

MEMENTO 19 (RED V, STUDY FOR NUIT AMÉRICAINE), 2018
Newspaper .3 mm aluminum offset plate
mounted on aluminum frame
68 x 99 x 2.5 cm — 26 3/4 x 39 x 1 in

MEMENTO 6, 2016
Newspaper .3 mm aluminum offset plates
mounted on aluminum frame
143 x 99 x 2.5 cm — 56 1/4 x 39 x 1 in

MEMENTO 15 (STUDY FOR NUIT AMÉRICAINE), 2018
Newspaper .3 mm aluminum offset plate
mounted on aluminum frame
68 x 99 x 2.5 cm — 26 3/4 x 39 x 1 in

MEMENTO 20 (FAREWELL, RED), 2019
Newspaper .3 mm aluminum offset plates
mounted on aluminum frame
132 x 288 x 3.5 cm — 52 x 113 3/8 x 1 3/8 in

MEMENTOS

MEMENTO 21 (FAREWELL, BLUE), 2019
Newspaper .3 mm aluminum offset plates
mounted on aluminum frame
132 x 288 x 3.5 cm — 52 x 113 3/8 x 1 3/8 in

MEMENTO 26 (TEHRAN), 2020
Newspaper .3 mm aluminum offset plates
mounted on aluminum frame
137 x 198 x 2.5 cm — 54 x 78 x 1 in

MEMENTO 22 (DETESTABLE ACT), 2019
Newspaper .3 mm aluminum offset plates
mounted on aluminum frame
96 x 132 x 2.5 cm — 37 3/4 x 52 x 1 in

MEMENTO 23 (RED VI, TEHRAN), 2020
Newspaper .3 mm aluminum offset plate
mounted on aluminum frame
69 x 99 x 2.5 cm — 27 1/8 x 39 x 1 in

MEMENTO 24 (STUDY FOR TEHRAN I), 2020
Newspaper .3 mm aluminum offset plate
mounted on aluminum frame
69 x 99 x 2.5 cm — 27 1/8 x 39 x 1 in

MEMENTO 25 (STUDY FOR TEHRAN II), 2020
Newspaper .3 mm aluminum offset plate
mounted on aluminum frame
69 x 99 x 2.5 cm — 27 1/8 x 39 x 1 in

VIDEOSCULPTURES

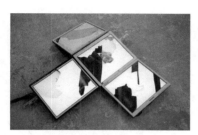

VIDEOSCULPTURE I (VICTORY SPEECH I), 2015
LCD screens, polarization filter, metal, cables,
video 25 minutes 59 seconds
120 x 140 cm — 47 1/4 x 55 1/8 in

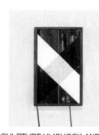

VIDEOSCULPTURE VI (SHOCK AND AWE), 2015
LCD screen, polarization filter, cables,
video 7 hours 24 minutes
50 x 30 cm — 19 3/4 X 11 3/4 in

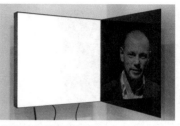

VIDEOSCULPTURE XIII (CENTRAL ALBERTA), 2017
LCD screen, black glass, metal, cables,
HD video 46 minutes 30 seconds
39 x 39 x 47 cm — 15 3/8 x 15 3/8 x 18 1/2 in

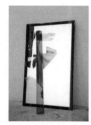

VIDEOSCULPTURE II (MAREK), 2015
LCD screen, polarization filter, cables,
video 14 minutes
100 x 50 cm — 39 3/8 x 19 3/4 in

VIDEOSCULPTURE VIII (LOOKING GLASS II), 2016
LCD screen, polarization filter, cables,
video 7 minutes 22 seconds
44 x 27 cm — 17 3/8 x 10 5/8 in

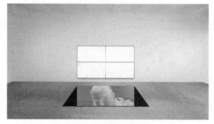

VIDEOSCULPTURE XIV (SHUDDER), 2017
LCD screens, black glass, cables,
HD video 7 minutes 13 seconds
206 x 117 x 130 cm — 81 1/8 x 46 1/8 x 51 1/8 in

VIDEOSCULPTURE III (PHILLIPINES), 2015
LCD screen, polarization filter, cables,
video 4 minutes 9 seconds
50 x 30 cm — 19 3/4 x 11 3/4 in

VIDEOSCULPTURE IX (PHILIPPINES II), 2016
LCD screen, polarization filter, cables,
video 4 minutes 9 seconds
50 x 30 cm — 19 3/4 x 11 3/4 in

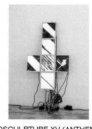

VIDEOSCULPTURE XV (ANTHEM), 2017
LCD screens, polarization filter, cables, metal,
video 2 minutes 14 seconds
200 x 130 cm — 78 3/4 x 51 1/8 in

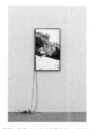

VIDEOSCULPTURE IV (VICTORY SPEECH II), 2015
LCD screen, polarization filter, cables,
video 25 minutes 59 seconds
110 x 60 cm — 43 1/4 x 23 5/8 in

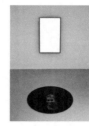

VIDEOSCULPTURE X (CENTRAL ALBERTA), 2016
LCD screen, black glass, cables,
HD video 46 minutes 30 seconds, height 121 cm,
diameter 96 cm — height 47 5/8 in, diameter 37 3/4 in

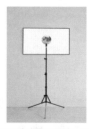

VIDEOSCULPTURE XVI (WHITE NOISE), 2018
46-inch LCD screen, polarization filter, plexiglass, tripod, cables,
HD video 38 minutes 13 seconds
height 180 cm — height 70 7/8 in

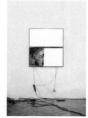

VIDEOSCULPTURE V (VATICAN), 2015
LCD screen, polarization filter, cables,
video 1hour 15 minutes
120 x 110 cm — 47 1/4 x 43 1/4 in

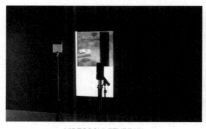

**VIDEOSCULPTURE XII
(EVERYTHING NOW IS MEASURED BY AFTER), 2016**
Triptych of LCD screens, polarization filter, plexiglass, 8 tripods,
cables, video 47 minutes, dimensions variable

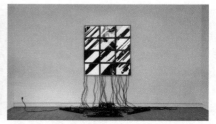

VIDEOSCULPTURE XVII (O'HARA'S ON CEDAR ST.), 2018
LCD screens, polarization filter, metal, cables,
HD video 20 minutes 34 seconds
180 x 112 cm — 70 7/8 in x 44 1/8 in

VIDEOSCULPTURES

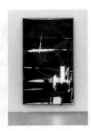

VIDEOSCULPTURE XVIII (O'HARA'S ON CEDAR ST II), 2018
LCD screen, polarization filter, metal, cables,
HD video 19 minutes 52 seconds
205 x 115 cm — 80 3/4 x 45 1/4 in

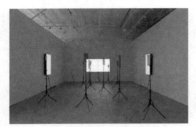

VIDEOSCULPTURE XX (THE WORLD'S 6TH SENSE), 2019
6 LCD screens, polarization filter, plexiglass, 10 tripods, cables,
HD video 13 minutes 34 seconds
dimensions variable

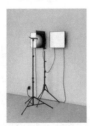

VIDEOSCULPTURE XXI (VEGAS), 2019
2 LCD screens, polarization filter, plexiglass, 2 tripods, cables,
HD video 12 minutes 40 seconds
181 x 96 x 75 cm — 71 1/4 x 37 3/4 x 29 1/2 in

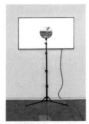

VIDEOSCULPTURE XXII (WHITE NOISE), 2020
55–inch LCD screen, polarization filter, plexiglass, tripod, cables,
HD video 38 minutes 13 seconds
height 190 cm — height 74 3/4 in

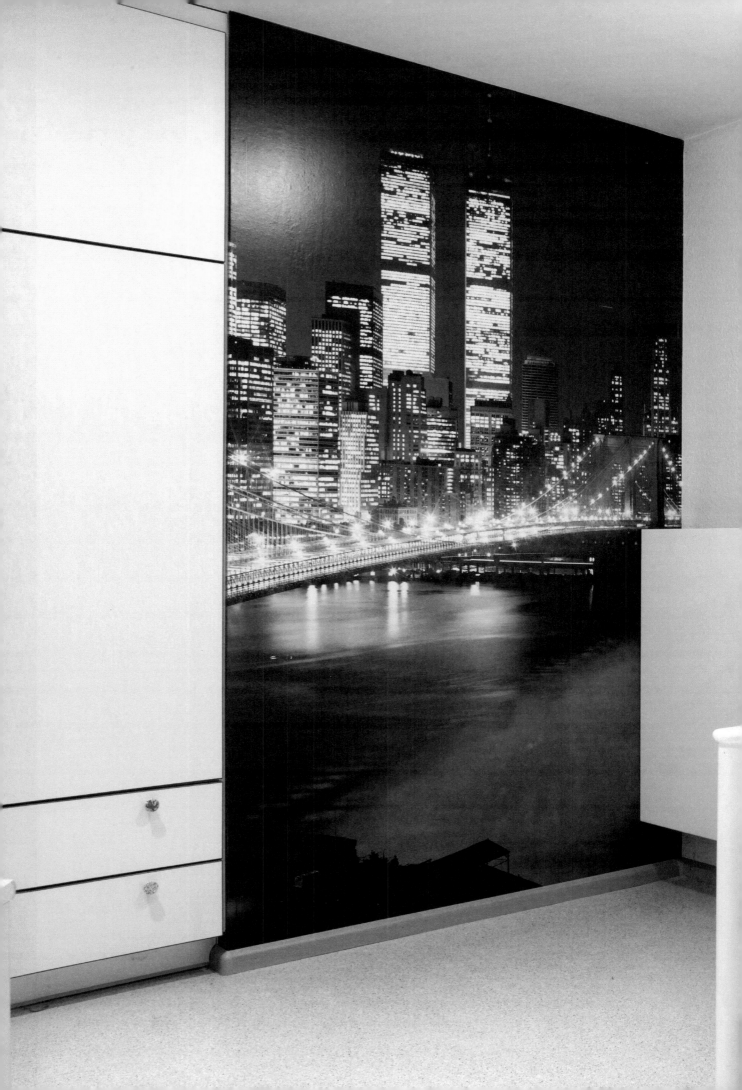

AFTERTHOUGHTS

I first met Emmanuel Van der Auwera in 2014, when the novelist Oscar van den Boogaard invited me to guest lecture at the Higher Institute for Fine Arts (HISK) in Ghent, where Emmanuel had been a resident for two years and Oscar artistic director for more than five. The HISK is one of Belgium's many unique instruments nourishing young artists. Along the way, Emmanuel has also received mentorship from the WIELS residency program, as well as support from events and organizations like the Young Belgian Art Prize, La Biennale de l'Image Possible, the Fédération Wallonie–Bruxelles (French Community of Belgium), and the Vlaams Gemeenschap (Flemish Community of Belgium). Having lived in Belgium for twenty years, I believe that the country's phenomenal appetite, education, and opportunities for and around the arts should be mentioned in any survey of a single Belgian artist's work. There are not many places where art is so valued that it becomes part of a broader civic vocabulary, and perhaps even fewer that provide as many critical avenues to adventurous young artists.

Emmanuel and I spoke for hours during that first visit in Ghent, discussing his recurring trips to NYC to commemorate 9/11, the Twin Towers poster that had adorned his childhood bedroom, his eerie visit to picturesque Rockport, and just why he first took a knife to an expensive TV and began shredding its screen. Since then, we speak almost daily, and have continued our conversations on art, politics, aesthetics, and transatlantic cultural differences as our partnership carries us back and forth across the Atlantic Ocean.

This publication focuses on three strains within Emmanuel's oeuvre, and we have invited three curators who have long known him and followed his practice

to unpack each one. Justine Ludwig's introduction connects these strains to the urgency of now. I would like to extend my personal thanks to Justine, as well as to Caroline Dumalin, for bringing Emmanuel's voice into this book; Ive Stevenheydens, for his thoughtful analysis of the "Memento" series; and Hans Maria De Wolf, for putting the artist in complex territory. Each chapter returns us to emerging technologies, tragic events, and how the recontextualization of media artifacts reveals the aesthetic and ethical challenges to consensual spaces and notions of democracy. The authors elaborate on the different ways in which Emmanuel's production shares a meaningful investigation into technical mediation's mise en abyme and the pitfalls of Postmodernism.

Yet there are a few other aspects worth bringing to the fore. Emmanuel focuses on the ethical imperative of being active before the screen. As he explores the overlap between physical and virtual constructs, the body becomes a primary site of knowledge and engagement. There is more to it than "meat puppets" and cyberpunk in the age of pubescent AI. The flesh matters, and matter may matter more as we progress down this road. We cannot afford to be passive receivers before any of his three-dimensional works. Well, not if we want to try and see something, that is. Emmanuel asks us to embody different postures and positions in order to observe from seemingly obscure angles. A full picture comes into view only by assembling fragments revealed from each one.

This makes his photo-based works incredibly challenging to photograph. They resist reproduction, embracing ephemerality, or at least their own transience. While Emmanuel often works with rather clunky tools from mass media, as elements of artworks they lose their industrial qualities and circulate as extremely fragile objects. One bump to the offset plates, one slice too deep of a screen, and they are damaged or even broken.

This brings us to another point. The more you expose something to light, the less visible it becomes. This is true of photography, but also of both the "VideoSculpture" and "Memento" series, which are, in part, reflections on the impact of communication technologies today. Overexposure begets invisibility, and the early twenty-first century's "be the media" promise of countercultural groups has given way to influencers and clickbait propaganda.

Then there is the question of the frame, essential to photography, cinema, linguistics, and mass communication. Emmanuel illustrates how narratives today move between and beyond frames. In his three types of "VideoSculpture," for example, one creates a cinema in negative, another inserts moving images into the plane between body and screen, and a third leaves traces of the sculptor's gestures as an impetus to discuss how an image is filtered in production, dissemination, digestion, and framing.

I am often asked if Emmanuel's work is political. My opinion is that it is, but only in so far as all artwork is political. His works are grounded in the documentary practice of an observer reporting on the time in which he lives and made using readily available technologies that alter and record the way we read and react. No answers to current dilemmas are brought forward, no political opinions are explicitly shared. Instead, what these works provide are tools with which we may seek conclusions on our own. They help us to understand what it may mean to navigate an image-saturated world that exists as much as it doesn't. For this I am grateful.

Harlan Levey

EMMANUEL
VAN DER AUWERA:
A CERTAIN AMOUNT
OF CLARITY

PUBLISHER
Mercatorfonds
Bernard Steyaert,
Managing Director

EDITORS
Harlan Levey
Amanda Sarroff

AUTHORS
Hans Maria De Wolf
Caroline Dumalin
Justine Ludwig
Ive Stevenheydens

TRANSLATION
Nina Janssen

PRODUCTION
COORDINATION
Wivine de Traux,
Mercatorfonds

BOOK DESIGN
AND TYPESETTING
Caroline Wolewinski

PHOTOGRAPHY
Ludovic Beillard
Steven Decroos
Philippe De Gobert
TR Ericsson
Carolina Gestri
Alexis Gicart
Gilles Ribero
Jean-Jacques Serol
Laure Cottin Stefanelli
Kevin Todora
Hugard & Vanoverschelde

DIGITAL EDITING
David de Beyter

COLOR SEPARATION,
PRINTING,
AND BINDING
die Keure, Bruges

TYPESET IN
Pirelli Regular & Italic

PRINTED ON
Munken Lynx Rough 100g,
MultiArt Gloss 130g

COVER
*Memento 20
(Farewell, Red)*, 2019

© 2020
Mercatorfonds
Works of art
© Emmanuel
Van der Auwera
Texts © the authors
Images © the
photographers

Distributed in Belgium,
the Netherlands,
and Luxembourg by
Mercatorfonds, Brussels
ISBN ENG 978-
94-6230-259-4
D/2020/703/25
www.mercatorfonds.be

Distributed outside
Belgium, the Netherlands,
and Luxembourg by
Yale University Press,
New Haven and London
yalebooks.com/art
— yalebooks.co.uk
ISBN YALE 978-0-
300-25394-8
Library of Congress
Control Number:
2020946546

This publication was
made possible with
the generous support of:
Dominique
and Marco Bronckers
Thomas Depas
Luc and Mylène Depuydt
Beatrice de Gelder
Luc Freche
Jeremy Epstein
and Charlie Fellows
Olivier Gevaert
André and Solange
Goldwasser
Frederick Gordts
Marguerite Hoffman
Theresa Simons
and James Lafond
Michèle and
Jean-Louis Rollé
Ferry Saris
Nikolaus Tacke
Philippe Van der Auwera
Anne Vierstraete